# A PICTORIAL HISTORY
# OF HUNGARIAN ART

# A PICTORIAL HISTORY OF HUNGARIAN ART

With an Introduction by
József Vadas

CORVINA

Originally published as A Magyar Művészet Képeskönyve,
Corvina, 1997

Translated by Ildikó Noémi Nagy

Text copyright © József Vadas, 1998

Translation copyight © Ildikó Noémi Nagy

ISBN 963 13 4531 7

Published by Corvina Books, Ltd.
Vörösmarty tér 1, 1051 Budapest

The book you hold in your hand tells the story of almost one thousand years of Hungarian art. By opening to the first illustration, you will find the Coronation Mantle dating from 1031, and if you flip to the end, you will find the photo of the monument erected for the martyrs of the Revolution of 1956, inaugurated on June 16, 1992, which stands today in the cemetery of Rákoskeresztúr. In between this beginning and end are more than one hundred other requisites from Hungary's past. Too many? Too few? We know how much was lost: from the Medieval wall paintings through King Sigismund's Gothic castle that once stood in the Castle District of Buda, to King Matthias' famous library of illuminated codices, the Bibliotheca Corviniana, which once consisted of over twenty thousand volumes but was dispersed into the national libraries of cities such as Paris, Rome, and Vienna, to the "golden" wall tapestries of the late Renaissance, the treasures of Esterháza, seat of the Esterházy princes, and the collections of the industrial magnates from the beginning of the 20th century, which were mainly taken to Russia as spoils of World War II.

During the last two centuries, the respect for fragments, ruins, and remnants has dramatically grown. Until then, intact reminders were sacrificed for the sake of the innovative; there was no hesitation in destroying the old for the sake of the new- especially if it was "bigger and better". In this way, many works were lost for succeeding generations; among these were Giotto's works in the Lateran and the Vatican, when St. Peter's Basilica was rebuilt. However, from the end of the 18th century and the beginning of the 19th, a new consciousness emerged. This historical consciousness was evident, for example, in the works of Piranesi, who found inspiration in the art of antique Rome, as well as Caspar David Friedrich, who turned in both subject and style to the Romantics. Yet another indicator of this change could be found in the French gardens of the most splendid castles, including the Esterházy estate, where one could invariably happen upon some sort of stone sculptures reminiscent of Antiquity.

The attraction towards the past has stayed with us until this day. Tivadar Csontváry Kosztka painted his most important works at the base of the broken columns in the antique world. Similar to his contemporary Van Gogh, Csontváry also suffered painful experiences throughout his lifetime; like Gauguin, he chose the land of ancestral cultures as his escape from "civilization". His travels took him to Palestine, Athens, and Herculaneum. One of the most spectacular of his paintings in this volume was inspired by the remains of the Greek Theater in Taomina.

How could we not respect the remains of the past? They demonstrate that art, in an everyday sense, has no real use, yet is not meaningless. Look back to the Coronation

Mantle once again. It was originally a chasuble used for the coronation of Stephen I., founder of the Hungarian State. Commissioned by Queen Gizella, his wife of Bavarian descent, the mantle was most likely fabricated from a Geman pattern. Its original material, probably Byzantine silk, deteriorated to such an extent over time, that much of it had to be replaced. It was reinforced twice throughout the centuries. Today only traces can be found of the original. The once thick embroideries remain only in mere contours. Though it has been eaten away by age, it has no match, because the hand of time, as well as those of the embroiderers, have left their mark.

The fact that time forms not only the outer substance, but also the meaning and aura of works of art, is a 20th century discovery. Some contemporary artists, like György Jovánovics, work by imitating archaic surfaces, deriving their materials from discarded fragments and remains of objects. Look back to the end of this book: his memorial to '56 is reminiscent of a dolmen, and is constructed of requisites. Constructing this monument in this way, he gives immortality to the Martyrs of freedom by illustrating tha what man creates leaves a pemanent trace.

This message is also conveyed by an altarpiece that, almost symbolically as it were, is chronologically right in between the Coronation Mantle and the Monument of '56. It was constructed by Master M.S. for the Church of Mary in the town of Selmecbánya, then northern Hungary, in 1506.

The work is a so-called "passion" altar. When opened, the reliefs and statues inside the altar's cabinets fastened onto the side wings is turned towards the worshipers. During Easter, the cabinets were closed exposing paintings of the Stations of the Cross, along with other pictures on the outer surfaces. However, the altar of Master M.S. does not merely carry symbolic meaning, but also alludes to the great centuries of Hungarian art, laden with masterpieces and sorrow.

The altar, three and a half meters (approx. 11 feet) high and five meters (approx. 16 feet) wide, probably consisted of eight tablets at the time. The four passion paintings (*Christ on the Mount of Olives, The Carrying of the Cross, Calvary, Resurrection*) found today in the Christian Museum of Esztergom, once formed the bottom part of the altar. The *Visitation* (the lyrically moving meeting of Mary and Elisabeth) is the pride of the Hungarian National Gallery in Budapest.

Not only is the altar of Master M.S. impressive in size, but it also bears artistic excellence. If you look at the way the folds on the clothes are painted, many attributes of the Renaissance style can be found; nevertheless, the spirit of a new age is present: the beauty of nature and of life are celebrated, the suffering of man is represented in the crucified Christ. The altar bears comparison with its notable contemporaries such as Grünewald's masterpiece, the Isenheim Altarpiece (c. 1510), found today in the museum of Colmar. Our study attempts to give a panoramic view of one thousand years of Hungarian art. By placing this magnificent altarpiece in the middle, we can look back as well as ahead with confidence.

1506: It is two decades after the death of King Matthias (1440–1490) politician, patron of the arts, and notable monarch of Hungary's golden years. It is also twenty years

before the defeat of the Hungarian armies by the Turk at Mohács in 1526. Hungary is still one of the great European states. However, while the Turks are a threat from the outside, the country's nobility slowly wears out the monarchy from the inside. The financial predicaments of King Ulászló II. are constant, while the power of the bourgeoisie is growing in the towns. These are the years before the importation of precious metals from the Americas, and many become wealthy from the copper, gold, and silver mines in the northern regions of Hungary. The mining city of Besztercebánya became important as well. Between 1477 and 1489, János Thurzó, owner of one of the most prosperous businesses, contributed in the crafting of the famous Altar of Mary in Krakow by Viet Stoss.

Selmecbánya wasn't as affluent as Besztercebánya, so Thurzó didn't expand his business to include the town. Nevertheless, Besztercebánya had its own magnate by the name of Boldizsár Steck, who also happened to be the Town Clerk. He was wealthy enough to lend money to Queen Beatrice, the widow of King Matthias (this was in 1497), and he still had enough left over so that Selmecbánya could buy the lead necessary for mining from Thurzó himself. Whether these business connections had any direct link to the commissioning of such a grand altarpiece remains the work of scholars. It is unquestionable, however, that the art of the Hungarian Renaissance admired by so many foreigners, and treated in books by Galeotto Marzio and Antonio Bonfini, was not limited to Buda, the country's capital. Many more examples, like the Castle of Visegrád, is remarkable, even though in ruins. In addition, the only intact reminder of early Renaissance architecture is the chapel in the Basilica of Esztergom. Commissioned by Archbishop Thomas Bakócz, it was designed by an architect from the circle of the great architect Sangallo, who also contributed to the designs of the Cathedral of Florence and Saint Peter's Basilica. Though only fragments remain of the splendor that directly surrounded the monarch, we can see that prominent Renaissance art decorated even the church of a relatively obscure city (in the form of a magnificent altarpiece).

Who was Master M.S.? Perhaps we will never know. It is possible that the German artist who initialed his stylistically similar works with the letters M.Z., is the culprit. What we do know for sure is that the artist who made the altar in Selmecbánya came from, or was educated in the style of the so-called Danube School which was inspired by Nürnberg. Viet Stoss himself went to Krakow from here. Scholars claim that many paintings of a young artist from Nürnberg could possibly be the early paintings of Master M.S. Of course, what complicates matters is that altarpiece painters often used etchings for inspiration. Master M.S. was probably no exception.

It is impossible to speak of a general national style at the end of the Middle Ages. Artistic styles were linked to individual artists, schools, and certain regions, like Tuscany or the northern area of the Danube. The masters journeyed from one city to the next, or even one country to the next. Many factors influence our view of the Hungarian Renaissance. Scholars noted that while the works of M.Z. were done in the style of the late German Gothic, they unquestionably blend the artistic inspirations of an Italian journey within them. In addition, the Italian masters commissioned by Queen Beatrice brought

the diverse effects of the Italian Quattrocento with them, but so did artists of the German Renaissance, who had also been to Italy.

The further we look back into the past, the more complex the kaleidoscope becomes. Let's look at the example of King Sigismund (1387–1437) for a moment. To pursue his ambitions of being an influential and powerful monarch, possibly emperor, he had recourse to various diplomatic maneuvers. He picked out plans for his castle in Buda from the specimens he saw around him in Avignon, London, and Paris; he even sent to Sienna for blueprints. No wonder that during a routine excavation in 1974, archeologists stumbled upon some relics of the late Gothic period. The existence of such relics was a surprise for everyone, since no clues suggested that such objects should exist. The original function of the statues, including ecclesiastical works and knightly portraits, is still unknown. What we do know from analysis is that these remnants probably came from a major Austrian workshop where at least one French master worked. This explains why the statues bear the hallmarks of the latest Parisian styles. This workshop, aside from the French influence, was the melting pot of assorted styles.

The international Gothic style appeared throughout Europe at the end of the 14th and the beginning of the 15th century. This modern label is explained by the fact that the artists of the time were more than willing to learn from each other, despite the fact that this was the age of the individual. Artifacts made their way to and from other countries in the form of gifts and commissioned work. King Sigismund sent ornamented bone saddles as gifts made in German workshops, while in turn he received gifts that today are considered Hungarian masterpieces. One of these is the Matthias Calvary, the upper part of which was made in 1401 for the King of France, while its base was made in 1489 by an Italian goldsmith working in the court of King Matthias. In addition, the Hungarians were brilliant goldsmiths. They made the most of the style that bloomed throughout the Gothic in the form of golden crosses, grails, and jewelry, and above all, the reliquary head of King Saint Ladislas and the highly ornate Suky Goblet. However, the work done on the most important Hungarian relic, the crown, was done by foreign hands. The bottom part, the Corona Graeca, was probably a gift from the Byzantine court for the wife of Géza I. around 1075. The top part, the Corona Latina, was probably constructed in southern Italy.

We are moving far away from the altar of Master M.S. in time as well as style. Yet by observing the past, we can see that a great change began in Hungarian art around the time of Master M.S.'s work. The greatest example of this shift is in the Selmecbánya altarpiece.

This change can be best understood if we take a look at the general way of thinking between the 15th and 16th centuries. It was around this time that the concepts of nationalism and patriotism emerged among the people. If we are to label the art before Master M.S. as Hungarian, then the altar is well within the boundaries of a specific Hungarian style: it can be distinctly separated from outside influences. It has its own unique characteristics, not just the style of a certain master or a school of thought. No matter how similar the contours of the *Visitation's* Maryare to the *Fortuna* drawing of Master M.Z.,

or the pages of Schongauer's *Wise and Foolish Virgins* series, the general atmosphere is dramatically different. Or as an art historian summarized, "The meeting of Mary and Elisabeth and the four paintings illustrating the birth and sufferings of Christ, are uniquely Hungarian."

History sometimes repeats itself. When the first Hungarians arrived on the Carpathian plains in the 9th century, they decorated objects with specifically individual Eastern motifs. The motifs could be discovered on some wood carvings in the 11th century, but soon disappeared. The Hungarian monarchy assimilated to their surroundings in all respects: marriages, divorces, way of life. This integration was most evident in the arts connected with the ceremonies of European Christianity. The concept of the house was not unknown to the nomadic ancestors. However, the building of a church was a skill that the Hungarians could have learned only from their neighbors. We can thank the Benedictine and the Cistercian architectural orders for the intact churches of Ják and Bélapátfalva. We must not fail to mention the name of Villard de Honnecourt; in addition to assisting in the building of nine French cathedrals, including Chartres, Reims, Laon, and one German (Marburg), he also contributed to Hungarian churches in Eger, Esztergom, Gyulafehérvár, Ják, Kassa, Pilis and Zsámbék. Excavations in Pilis between 1960 and 1970 offered proof that Villard was in Hungary around 1230.

Did Villard actually design the churches, or was he simply the "manager"? Though we have no answer to this question, it is obvious that Hungarian art was in no way isolated during the Middle Ages. It merged with contemporary fashions. From here on, it developed along with the Renaissance style we have already discussed in connection with King Matthias.

Following history in this way, we can see the circumstances leading up to the production of the Selmecbánya altar. The mining cities in the 15th century produced other important works of art besides magnificent altarpieces, including the crypt of Garamszentbenedek around 1480. The Hungarian Humanist Movement was the pinnacle of centuries of intellectual development and assimilation. The northern regions united with this development in the 15th century, though we cannot speak of an independent Transdanubian or Western Hungarian art.

A unified Romanesque style developed more or less by the 12th century. Certain workshops were the core of this style, including the workshop of Pécs, and not much later, the workshop of Esztergom, which in the 13th century influenced the style of secular and ecclesiastical buildings in cities such as Vértesszentkereszt, Pilis, Buda, and Pannonhalma, as well as the monasteries of Bélapátfalva, Ják, and Lébeny. The shift of culture and trade from east to west as well as the emergence of modernization in the 13th century, played an important part in the future of artistic development. The *Illustrated Chronicle*, which documented the legends of Hungarian heroes and kings (for example, King Saint Ladislas) as history, and the *Hungarian Anjou Legend*, which chronicled the lives of Hungarian saints and was made in Bologna, document international connections, as well as a strengthening sense of Hungarian national identity.

Though we could bring up outstanding examples of late Gothic art, like the paintings

of the Anjou dynasty, the statues of King Sigismund's age, or the courts of King Matthias in Buda and Visegrád, we would be incorrect to assert that the brilliance found in the work of Master M.S. continued into later centuries of Hungarian art. History stepped in. Not only did the battles with the Turks tear the country into three parts, and result in the ill-fated siege of Buda, but during the 150 year occupation, beginning in 1541, the progression towards the western European model was aborted. For a long time, the Turkish years – 1541 through 1699 – were not taken into consideration by art historians. The statues of King Matthias' court were taken to Constantinople and made into canons, the Corvinas were dispersed, the church known today as Matthias Church was used as a gunpowder depot until it exploded, Filippino Lippi's painting of the *Last Supper* disappeared along with Mantegna's *Matthias Portrait*.

Today, of course, we realize that time did not cease to exist for 150 years. The Hungarians inherited several things from the Turks such as: the cult of the Turkish bath, certain foods, textiles and embroidery techniques, fashion (for example, the dolman, which is today considered a typically Hungarian piece of clothing), arabesque decorations on communion chalices. What we call "Transylvanian" rugs are actually Eastern (Usak) rugs; the style was adopted during their import to western Europe. During the Turkish occupation, Hungarian art found its refuge in folk art as well as in the religious artifacts of the Reformation. The continuation of the Hungarian Renaissance is evident in the houses of Transylvanian towns, and the painted wooden ceilings of village churches.

When, after the ousting of the Turk, Hungary became part of the Habsburg Empire, the country once again attached back on to Europe. However, this didn't mean that everything had to be started all over again. The Baroque took the place of the Romanesque and the Gothic. The main controlling force behind the innovation was the Catholic Church, which had just regained power after the onslaught of the Reformation. Romanesque and Gothic churches that somehow survived the stormy centuries received new Baroque façades, and some were entirely rebuilt, inside and out. Some famous examples include: the abbey in Tihany, whose crypt from the 11th century, is the the earliest intact architectural relic; the Franciscan Church in Keszthely, in which frescoes from the 14th–15th centuries were discovered, or the Parish Church of Pest, representing architecture from the beginning of the 15th century.

Some originals remained, though new churches became more characteristic; of these the best known is the Jesuit and later the University Church in Nagyszombat. In the cities of Székesfehérvár, Eger, Sopron Pécs, Szigetvár, and Gyula, even the streets were in the new style. Inside the churches, the golden altars, the paintings, the frescoes, the richly carved, architectonic pulpits, and other decorations seemed to overflow.

Many new talents emerged in the 17th century. Among them were: Jakab Bogdány (1660–1724), Ádám Mányoki (1673–1757), the lesser known János Spillenberger (1628–1679), and the internationally renowned János Kupetzky (1667–1740). They grew up in Hungary, possibly painted a few attractive still-lifes or portraits, but soon left the country, sometimes never to return. In this way, Bogdány ended up in London as favored painter of the aristocracy, Mányoki became the court artist of German and

Polish nobles; Jan Kupetzky was a favorite among Czechs. As soon as circumstances stabilized in Hungary, many masters arrived in large numbers, especially upon hearing about large-scale architectural constructions and the lack of workshops. Among the foreigners who cultivated Hungarian painting and spread the Baroque style were: István Dorfmeister (1725–c. 1797), János Kracker (1717–1796), Franz Sigrist (1727–1803), and Franz Anton Maulbertsch (1724–1796).

The golden age of castle building was the 18th century. We are aware of earlier castles, of course. Most of these survived the Turkish years as fortresses in cities such as Sárospatak, Sárvár, Hédervár. Many of the new castles were built by the aristocracy in French style. To mention only a few: the Esterházy family settled in Kismarton and Fertőd, the Grassalkovich family in Gödöllő, the Festetics family in Keszthely, the Széchényi family in Cenk, while the other branch of the Esterházy family moved to Pápa. Needless to say, this building frenzy was not restricted to aristocracy. The new castle in Buda was built above the ruins of the Medieval castle for the Palatine and employed Italian, Austrian, and German artists. The construction continued into the next century.

From the end of the 18th century, the funds started to dwindle. Neither the church nor the aristocracy had money to spare. Not only were the citizens powerless compared to western Europe, but could not even straighten out the dilemma of national independence and the fortification of a mother tongue. Ironic as it may seem, the nobles supported the independence of the peasants, since they no longer had any interest in keeping up the feudal system. Since this group lived poorly compared to the aristocracy and the Catholic Church, they did not begin any extensive construction and did not employ foreign masters. As it so often happens, necessily became the mother of "invention". From the beginning of the 19th century, Hungarian masters were at work. The development of a new Hungarian style in architecture and the arts was in no small measure fostered by the Enlightenment and the reawakening of national consciousness. The artists were not Baroque masters, but perhaps for this reason, they painted historical events, landscapes, and portraits closely related to the nation.

Empress Maria Theresa (1740–1780) ordered that drawing class should be mandatory in elementary school. At the same time, though, in the eastern part of the empire, including Hungary, almost a century had to pass before an institute of higher education was devoted to the training of artists. Until then, the would-be artists had to study at the Viennese Academy. Both the lives and works of János Rombauer (1782–1849) and Károly Markó the Elder (1791–1860), two important painters of the time, were typical. Rombauer was the son of a carpenter, and probably never attended the Academy, Markó left the field of engineering to paint, and ended up in Vienna at the age of thirty. Both left Hungary after their first success: one went to Russia, the other to Italy. Neither forgot about home, however. Rombauer returned around 1820, and was quite active, while Markó regularly sent paintings home for exhibitions, including the famous painting *Visegrád* (1826–1830).

The indicator of changing times was that many talented artists chose to stay at home. In the decades preceding the revolution of 1848, two esteemed painters provided the

example. Miklós Barabás (1810–1898) lived in Pest and made a living off portraits and newspaper lithographs – the equivalent of today's photographs. The life of the sculptor István Ferenczy (1792–1856) was not so easy. His work was expensive and not an everyday necessily. The sponsors for his greatest work – the equestrian statue in the honor of King Matthias – included the celebrated Hungarian poet Mihály Vörösmarty. The general public followed the news about Ferenczy's efforts, which shows that there was a new audience interested in sculpture.

The education of the public was important on the agenda of the Reform Age. To serve the citizens, the National Museum designed by Mihály Pollak (1773–1855) was erected in the neoclassical style. Most of its original collection was donated by Count Széchényi in 1802, and was later bought by the government to be added to the growing number of books, maps, coins, and other art works.

Though other neoclassical buildings were constructed throughout the country, like József Hild's cathedral of Eger, and the Basilica of Esztergom, and Mihály Péchy's Great Church of Debrecen, the most dynamic development was once again evident in the influential center of Pest-Buda. Though many buildings were destroyed, including the Lloyd palace (the hotel Atrium-Hyatt is in its place) and the old Vigadó Concert Hall (built by Frigyes Feszl between 1859 and 1864), Pest still has many buildings to be proud of, among them are the designs of József Hild, Mihály Pollack, and Matthias Zitterbarth the Younger.

Starting in 1840, the newly founded Art Society of Pest founded one year before, began the tradition of a yearly artistic exhibition. Many artists from home and abroad took part in these events, partly to sell their works, and partly in the hope of finding a sponsor. The failure of the War of Independence in 1848 and the succeeding autocracy set back any further progression for a decade. There was a so-called exhibition in 1851, but most of the artists removed themselves from "circulation".

The failure of 1848 set many artists and intellectuals to re-examine the country's history, its whys and wherefores. Historicism, the predominant style of the age, was the perfect vehicle for this. Concurrently, not only was there an active interest in museums, but soon an inquisitiveness towards the historical disciplines of ethnography and archeology followed.

The circumstances governing the present, however, created not only a new style, but new subject matter as well. It was forbidden to talk directly about the general mood and sorrows of the people followina the 1848 revolution, but it could be represented by the events surrounding the triumphal reign of King Matthias or the tragedy of the Turkish occupation. In this way, paintings about the distant past were born: *Corn Huskers* by Mihály Munkácsy, *The Recapture of the Castle of Buda in 1686* by Gyula Benczúr, frescoes by Károly Lotz and Mór Than in the National Museum. With their need for large-scale group composition, these historical paintings demanded the highest skills and great artistic virtuosity. Though Jakab Marastoni was running a school in Hungary since 1846, the leading artists of the centuy still went to famous academies in Vienna, Munich, and Paris to learn the tricks of the trade. The next generation of talent to emerge in the 1860's and

70's included Károly Lotz, Mihály Zichy and Mihály Munkácsy, and were able to fulfill their commissions from the Church and the wealthy layman alike to everyone's satisfaction. By producing high quality work, some were able to provide existential security as recognized artists abroad: Zichy in St. Petersburg, and Munkácsy in Paris.

By 1867 the Hungarian political élite and the Habsburgs came to an agreement. Finally the Hungarians won a degree of economic and cultural liberty within the Austro–Hungarian Empire. Artistic freedom was allowed and architectural constructions were begun on account of successful economic circumstances. Budapest became a cosmopolitan center by the turn of the century. Several public buildings and private mansions are connected to the name of Miklós Ybl (1814–1891), as well as his colleagues Alajos Hausmann (1847–1926), Imre Steindl (1839–1902), and Albert Schickedanz (1846–1915). These buildings were decorated by the statues of Adolf Huszár (1842–1885), Alajos Stróbl (1856–1926), György Zala (1858–1937), and János Fadrusz (1858–1903). The Museum of Fine Arts and the Műcsarnok (Palace of Exhibitions) were constructed by Schickedanz and György Zala for the 1896 Millennial celebrations of Hungary, and stand today in Hero's Square.

One of the first large historical exhibitions was held in 1876 for the benefit of flood victims. This exhibit of "Apllied Arts and Historical Memoirs" was especially important, because it was here that three parts of the altar of Master M.S. was presented to the public after many centuries.

This was the age when architects, musicians and fine artists discovered folk art and Transylvanian culture, which, through its geographical seclusion, was able to preserve the past. Artists turned in this direction even more after they realized that classical European culture was only capable of repeating itself. While western Europe was looking to primitive cultures for inspiration, Hungarian artists turned to folk art in Europe's eastern regions, which was regarded as similar in many aspects. These two worlds met in the work of Ödön Lechner (1845–1914), who used motifs of folk art and the art of India in decorating his exquisite buildings. Others, like the painter Tivadar Csontváry Kosztka (1853–1919), longed for the mystery of the East. Though Csontváry was educated in Munich, the majority of his huge canvases were filled with Eastern themes.

Around the same time, the Pre-Raphaelites, seen as the English predecessors of Art Nouveau, helped change the conception of the Middle Ages from barbaric to something more romantic. It was to this imaginary spiritual landscape that Csontváry's contemporary, Lajos Gulácsy (1882–1932), fled and it was from here that a new generation of architects took inspiration and combined it with Transylvanian motifs.

Yet another artistic movement bloomed at the end of the 19th century. Young Hungarian painters from the Academy in Munich moved to the mining town of Nagybánya and founded an artists' colony in 1896. These young artists, including Károly Ferenczy (1862–1917), Simon Hollósy (1857–1918), and István Réti (1872–1945), were inspired by the famous painting by Pál Szinyei Merse (1845–1920), *Majális* (Mayfair). One year later, Mihály Munkácsy (1844–1900) himself also painted a landscape in the Impressionist

style. The painting, *Dusty Road*, portrays Hungary's plains in a way that sharply differs from the fashionable styles of the time.

The plein air school inspired by the artists of Nagybánya was followed by the Post-Impressionist style of József Rippl-Rónai (1861–1927) and the Cubist-Fauve modernism of the group known as Nyolcak (The Eight) which included Károly Kernstok, Lajos Tihanyi, and Ödön Márffy. Soon thereafter, the avant-garde movement appeared, with Lajos Kassák (1887–1967) at its head. In 1916, he founded the journal MA (TODAY), in which – according to him – Hungarian art, or Activism, would not follow the old ways, nor coincide with the new, but simple flow with the times. His journal was similar to its foreing counterparts: the German *Der Sturm*, the Holland *De Stijl*, and the French *L'Esprit Nouveau*.

At the beginning of the 1920's, however, everyone went their separate ways. Sharp lines were drawn between new and old, avant–garde and conservative. At the same time, a predominant number of eminent artists left the country. The painter, photographer, and applied artist László Moholy-Nagy ended up Germany, Marcel Breuer and György Kepes went to America, while Victor Vasarely and Nicolas Schöffer moved to France. The ones who stayed were forced to compromise if they wanted to escape poverty.

This tragic division between the old and the new had a detrimental effect on Hungarian art. Overt the course of the last half century, only a few artists had the strength to withstand temptation and not to stray from their principles for the sake of petty authority, nor were they dazed by the overwhelming vision of the universal. Between the two world wars, this gave rise to the self-destructive art of Gyula Derkovits (1894–1934), the works of Lajos Vajda (1909–1941), which were inspired by Greek Orthodox icons, and in the 60's the art of Béla Kondor (1931–1970), which redefined classical Christian iconography in accordance with modern precepts.

As our quick journey though Hungarian art has shown, the altar of Master M.S. is not simply part of religious iconography. Its themes represent the feelings that afflict humanity as a whole. We can only hope that the memorial of '56 in the cemetery of Rákoskeresztúr is the last memento of sadness in which we all had our share.

*József Vadas*

*Plates*

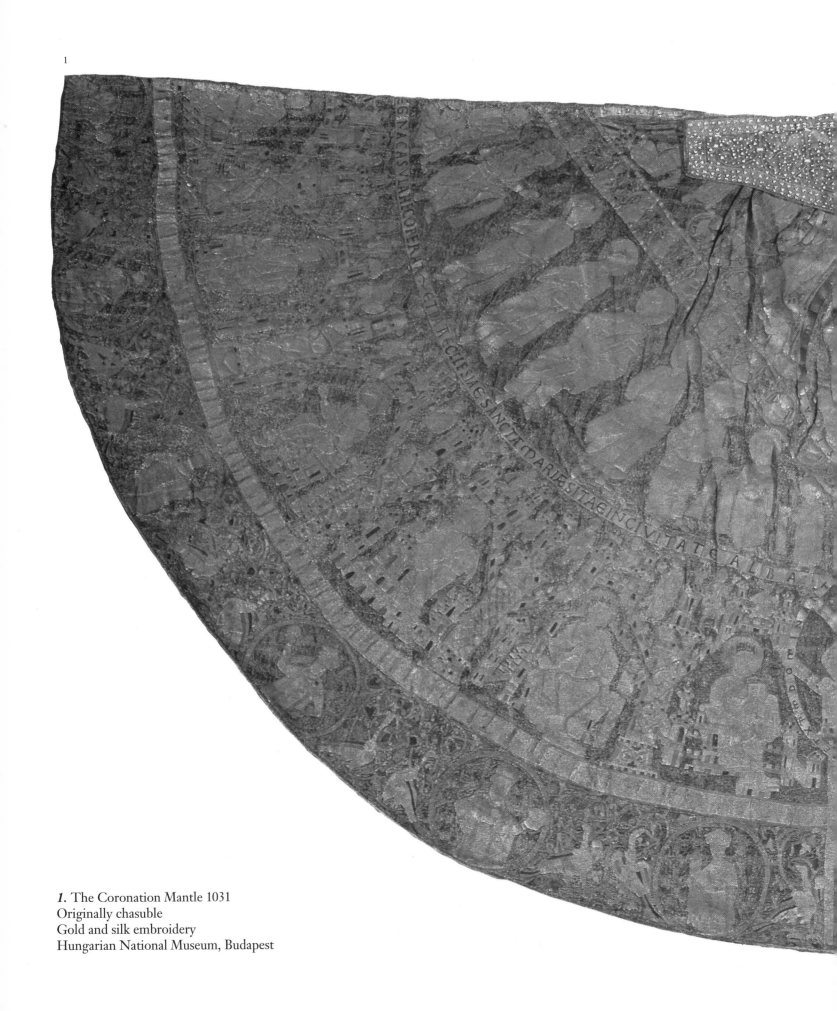

1

**1.** The Coronation Mantle 1031
Originally chasuble
Gold and silk embroidery
Hungarian National Museum, Budapest

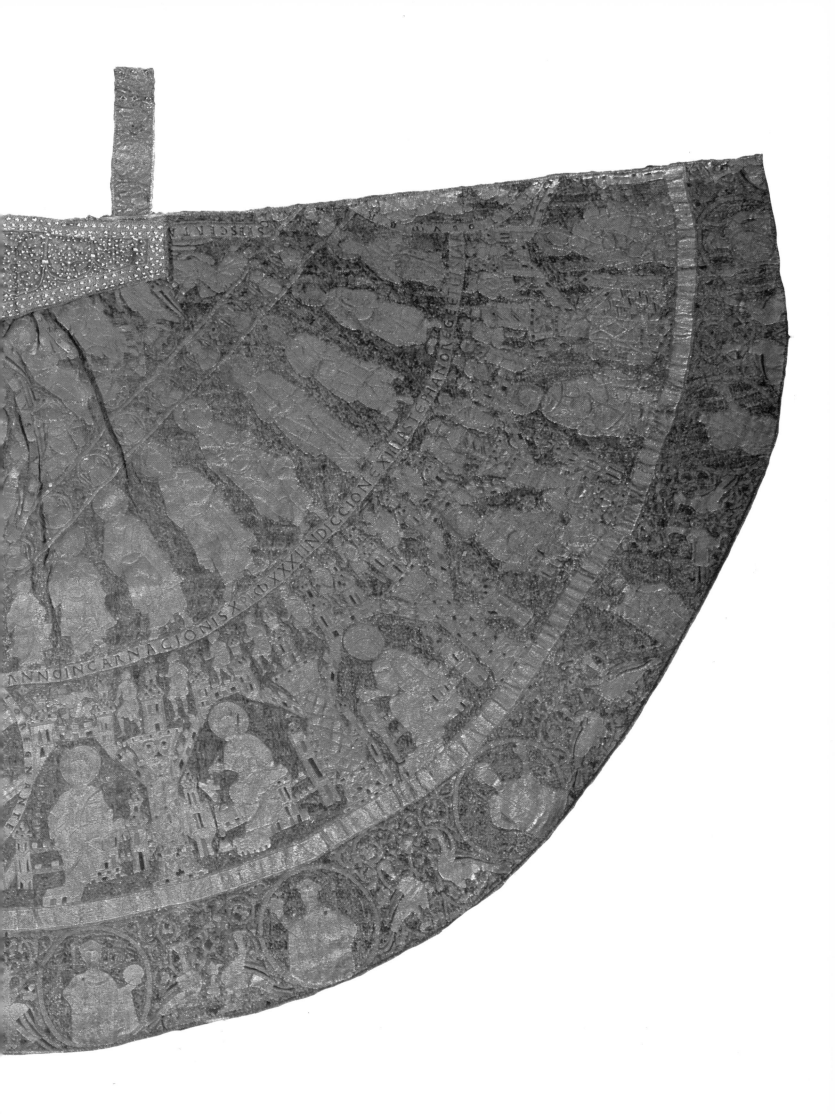

*2.* The crypt of the St. Martin Parish Church, Feldebrő
Second half of the 11th century

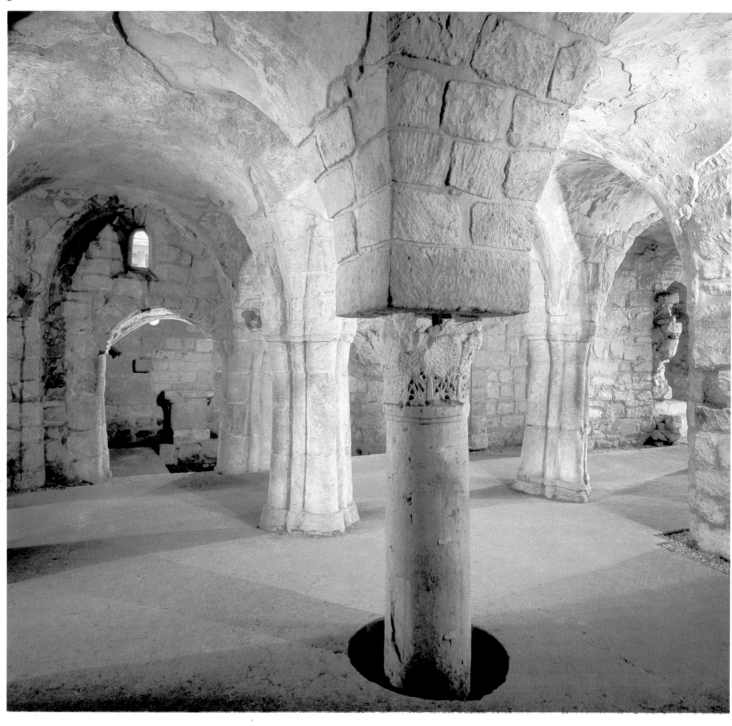

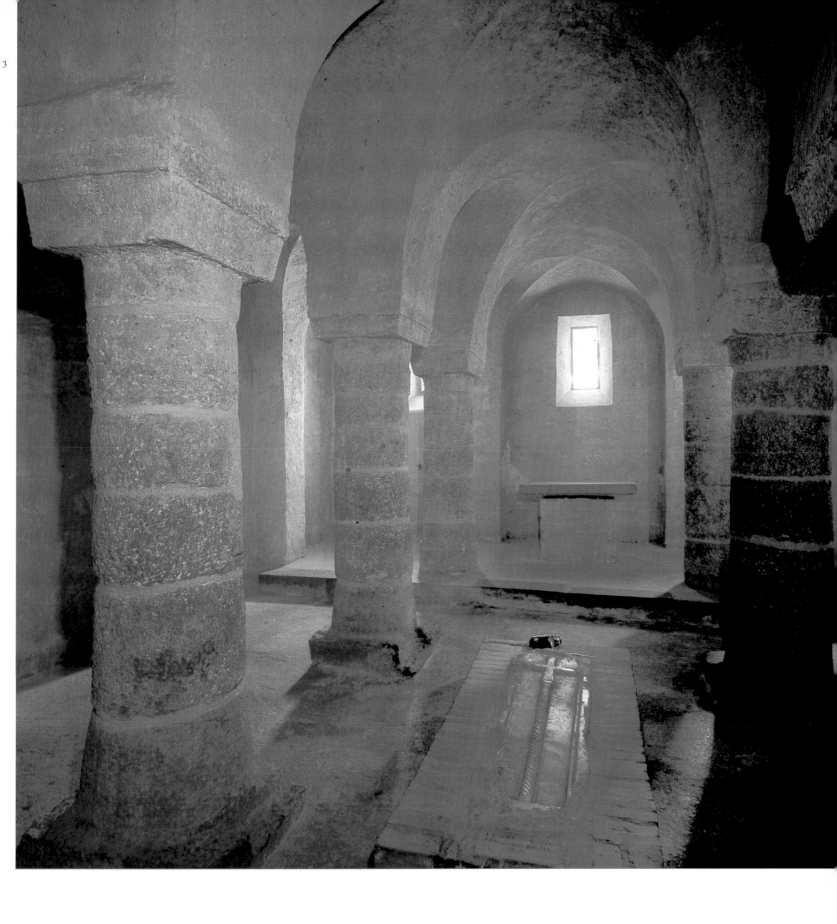

**3.** The crypt of the Benedictine Abbey Church, Tihany
Middle of the 11th century

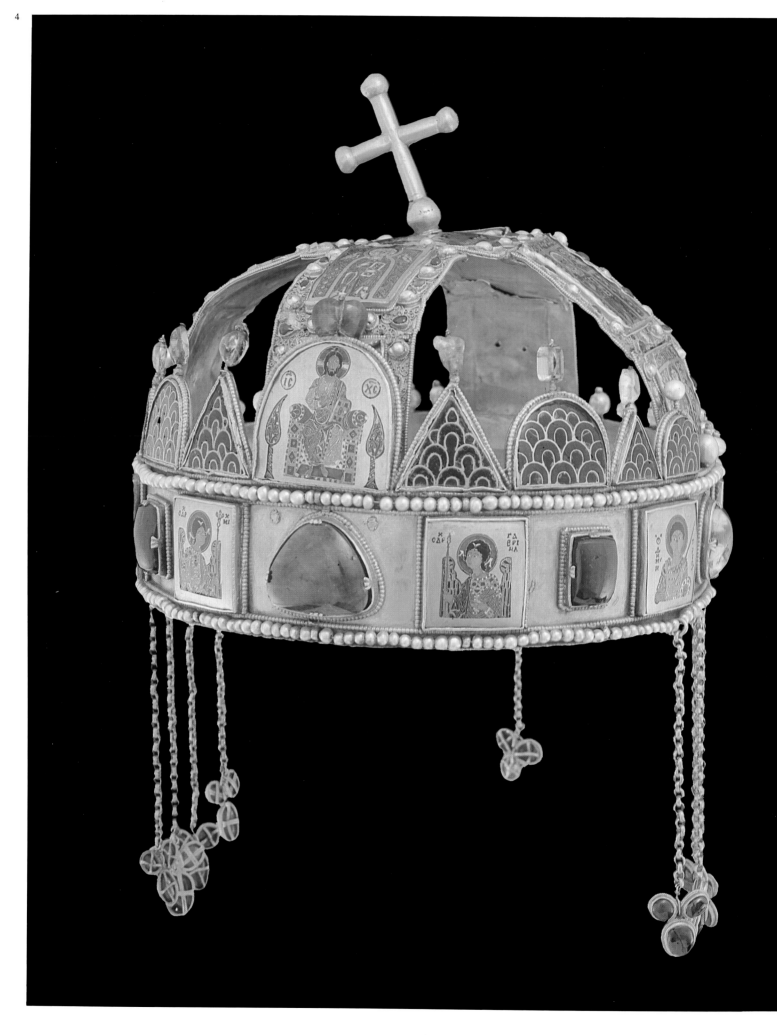

**SCS PETRVS**

*4.* The Hungarian Royal Crown
Bottom: 1074–1077; top: c. 1160–1180
Golden cloisonné enamel, pearls and semi-precious stones
Hungarian National Museum, Budapest

*5.* St. Peter on the Royal Crown
from the "corona latina" (detail)

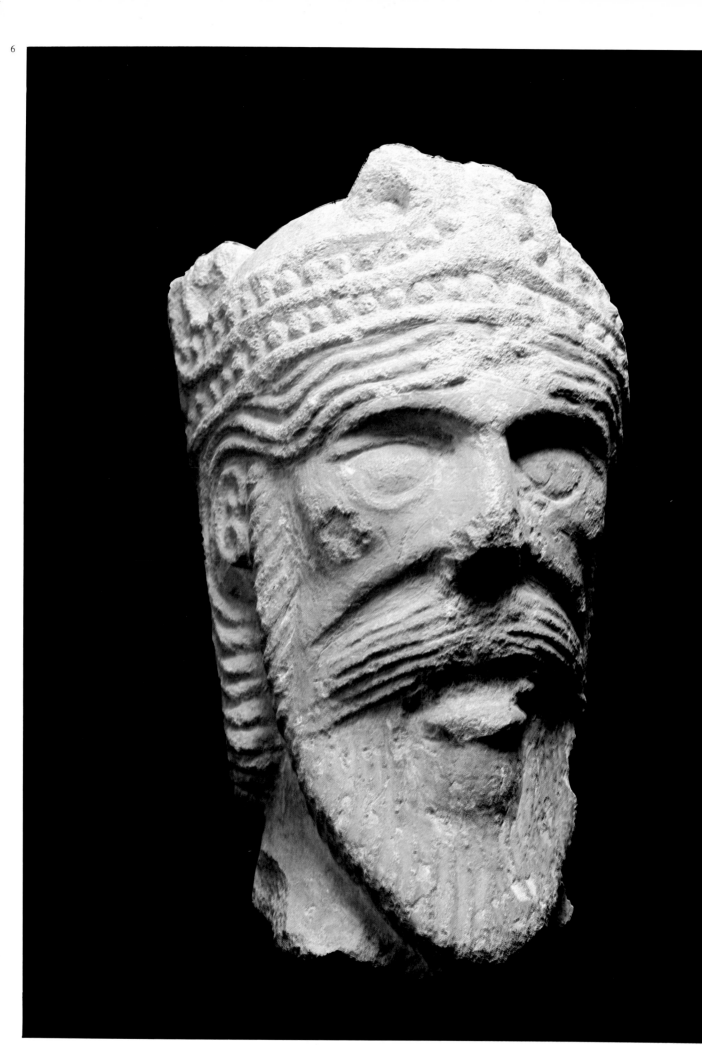

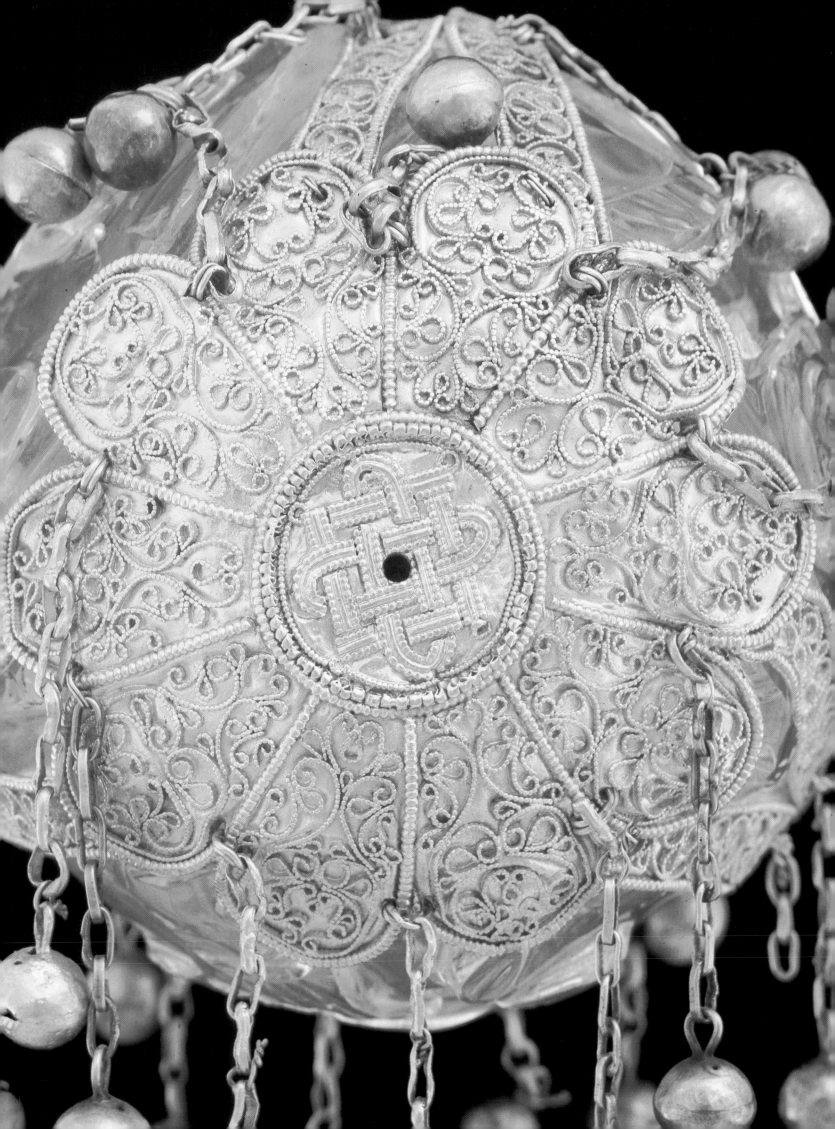

◁ **6.** Apocalyptic elder's head from St. Peter's Cathedral, Pécs
The last quarter of the 12th century
Sandstone with traces of paint
Collection of Stonework Finds, Pécs

◁ **7.** Top of the Hungarian Royal Scepter, late 12th century
Bent gold plating with filigree work over crystal
Hungarian National Museum, Budapest

**8.** Former church of the Cistercian Abbey, Bélapátfalva
Second quarter of the 13th century

**9.** King's head, Kalocsa
Early 13th century
Redmarble
Hungarian National Gallery, Budapest

8

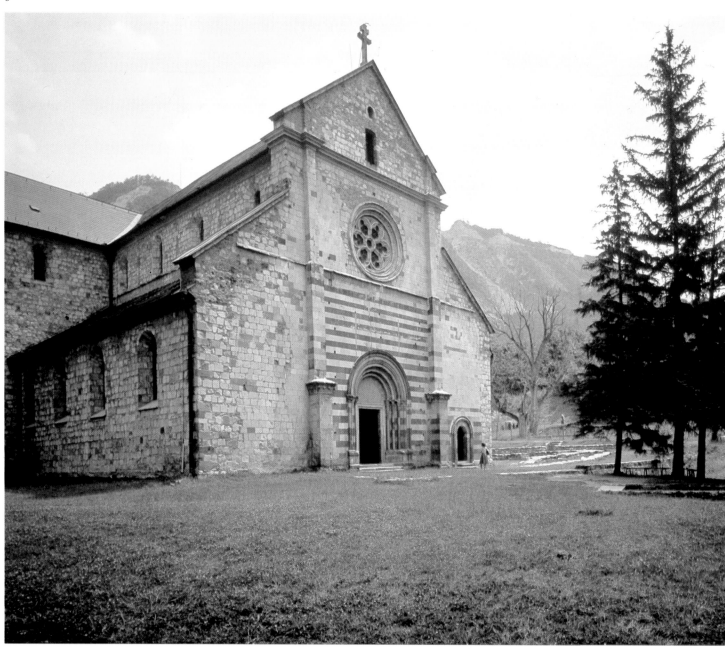

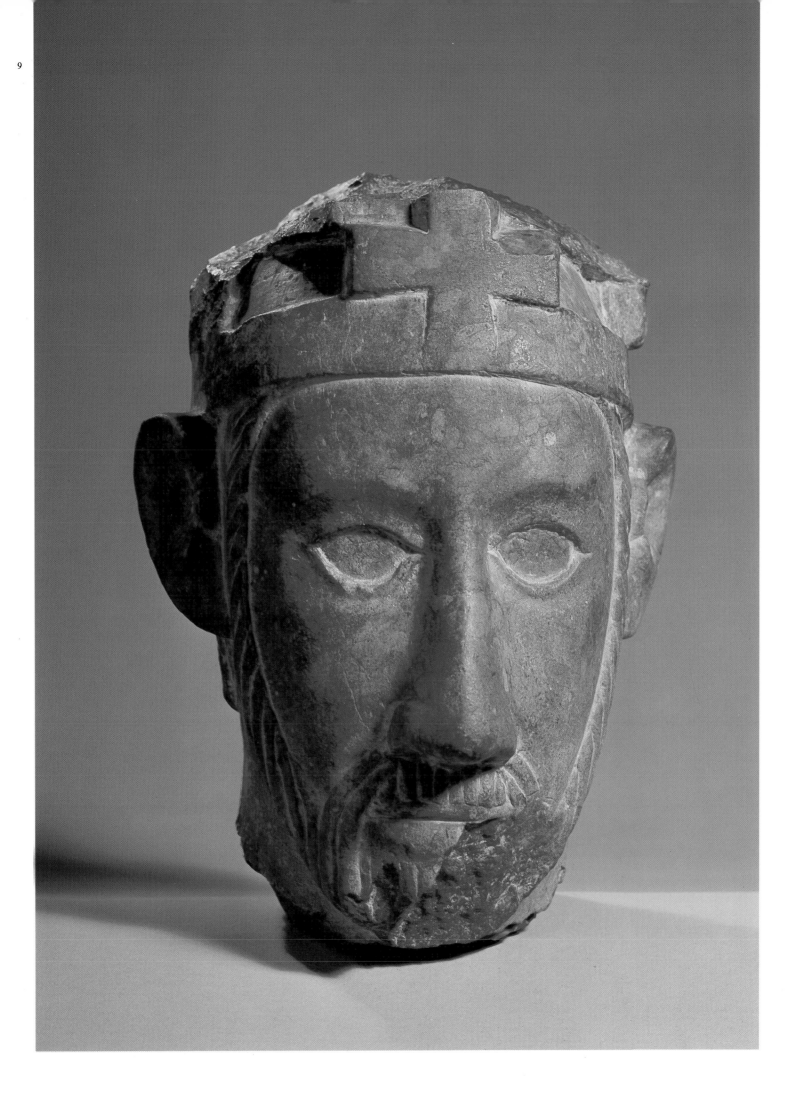

**10.** Former church of St. György of the Benedictine Abbey of Ják
First half of the 13th century

**11.** Gate of the Church of Ják
1230's

**12.** Overlayed columns of the Church gate of Ják
1230's

**13.** Lion from the façade of the Church of Ják
1230's

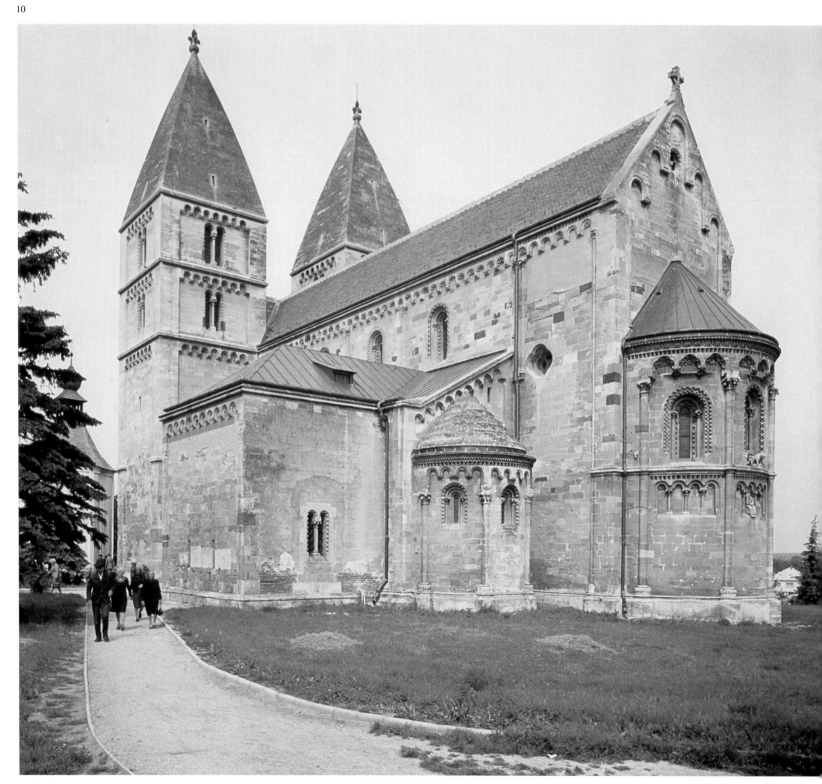

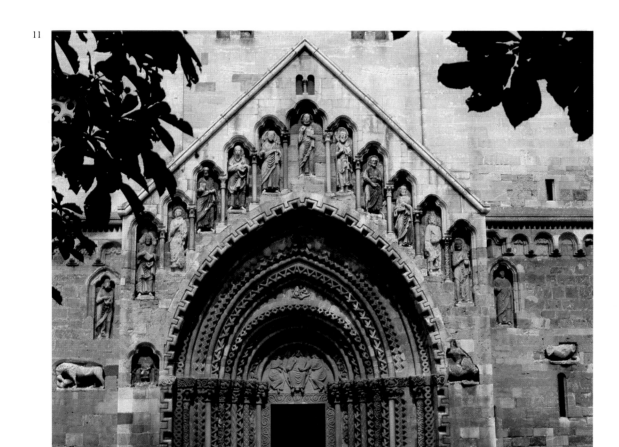

11

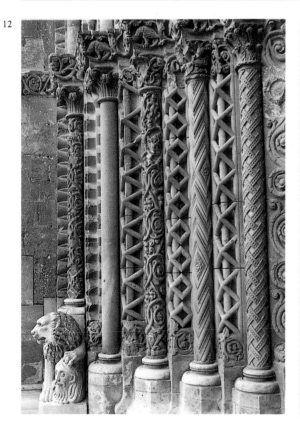

12

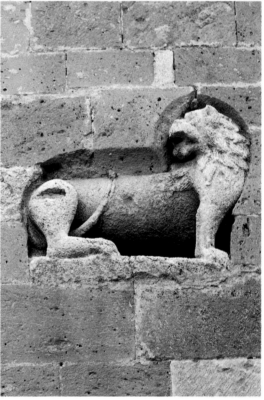

13

**14.** Fresco from the Presbyterian Church, Ócsa
Second half of the 13th century

14

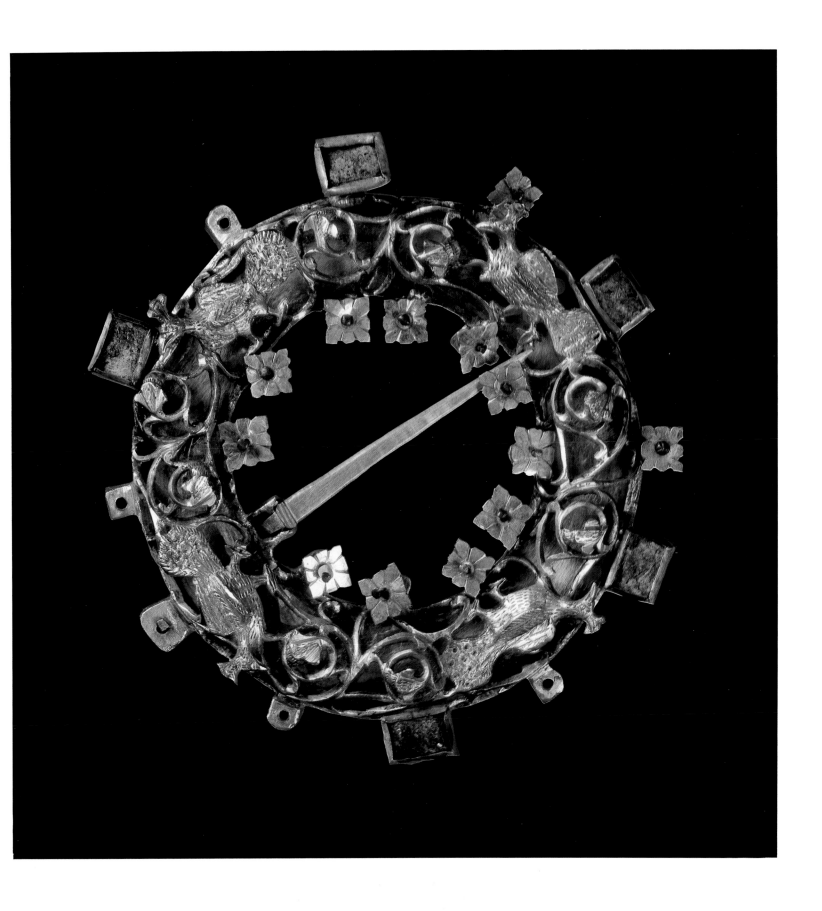

**15.** Cloak pin with peacocks
Second half of the 13th century
Gold plated silver
Hungarian National Museum, Budapet

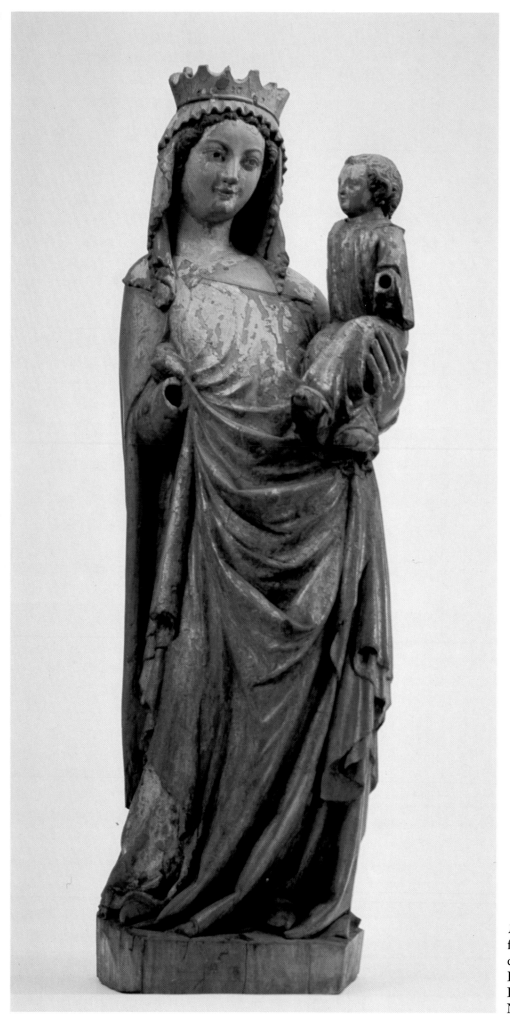

*16.* Madonna I.
from Toporc
c. 1340–1360
Painted linden wood
Hungarian
National Gallery, Budapest

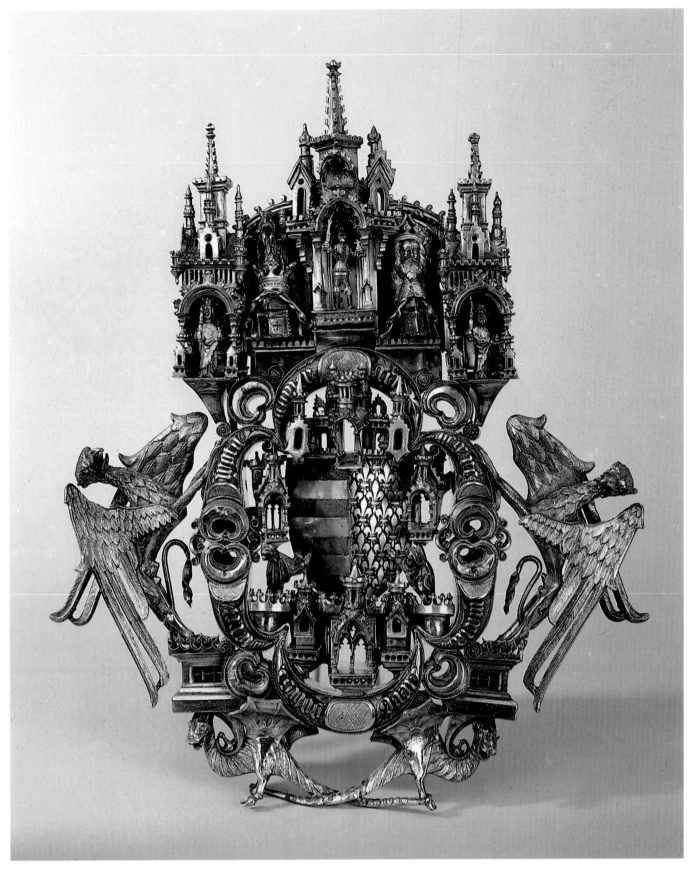

**17.** Cloak pin with the Hungarian Anjou coat-of-arms
Gold plated silver with enamel
Domschatzkammer, Aachen

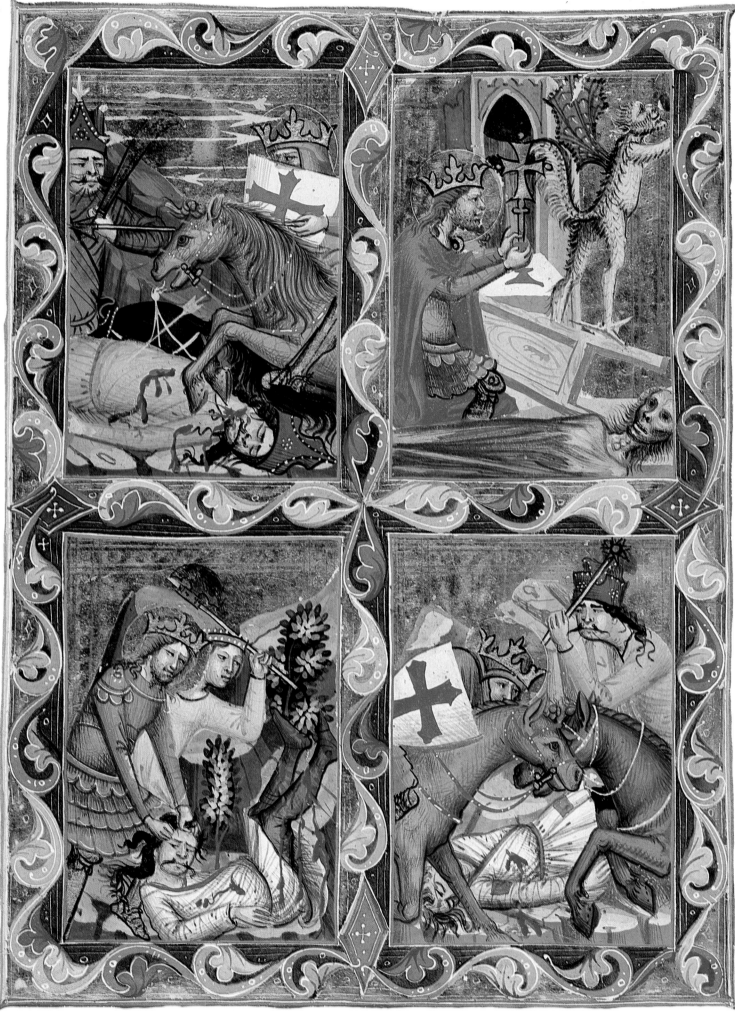

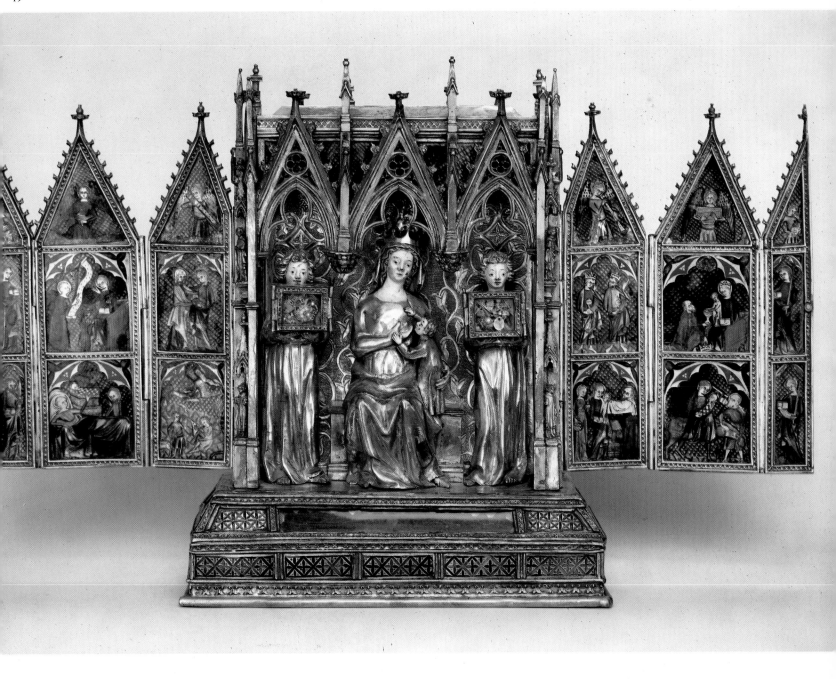

**18.** Scenes from the Legend of King Saint Ladislas.
Illustrations from *The Hungarian Anjou Legend*, 1330–1340
Biblioteca Apostolica Vaticana, Rome

**19.** The domestic altar of Queen Elisabeth from the Church
of Poor Claires in Óbuda, 1340–1350
Gold plated silver with paint
Metropolitan Museum, New York

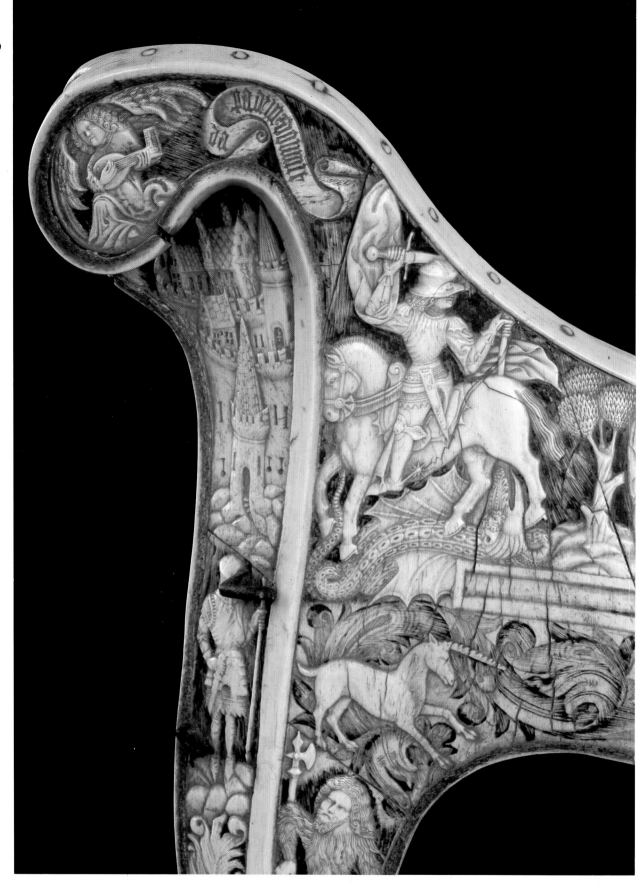

**20.** St. George and the Dragon on a bone saddle (detail)
Late 14th century
Hungarian National Museum, Budapest

**21.** Cover of the *Illustrated Chronicle*, c. 1360
Széchényi Library, Budapest

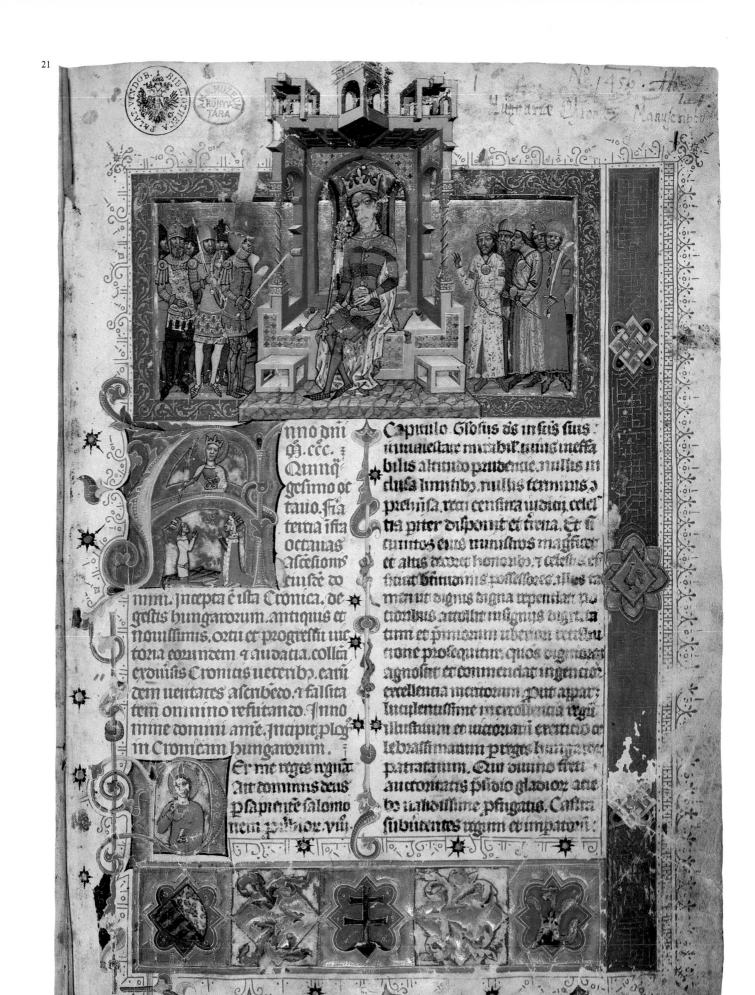

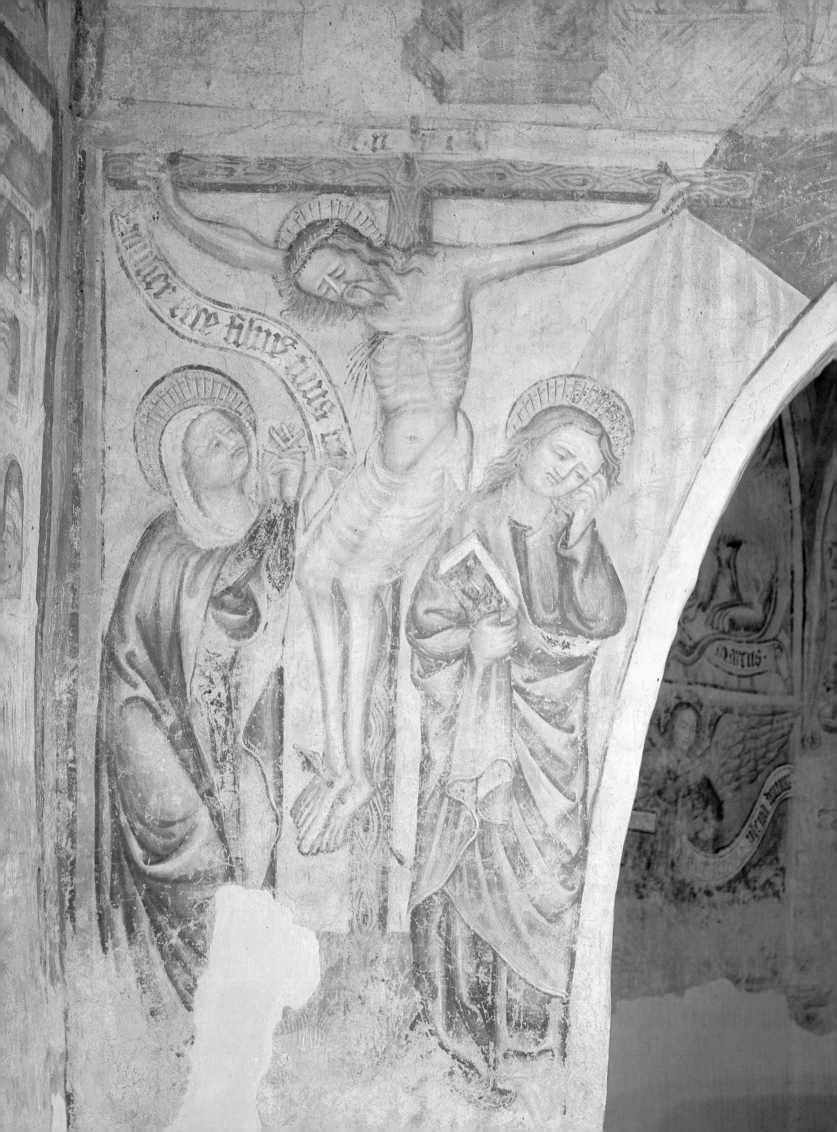

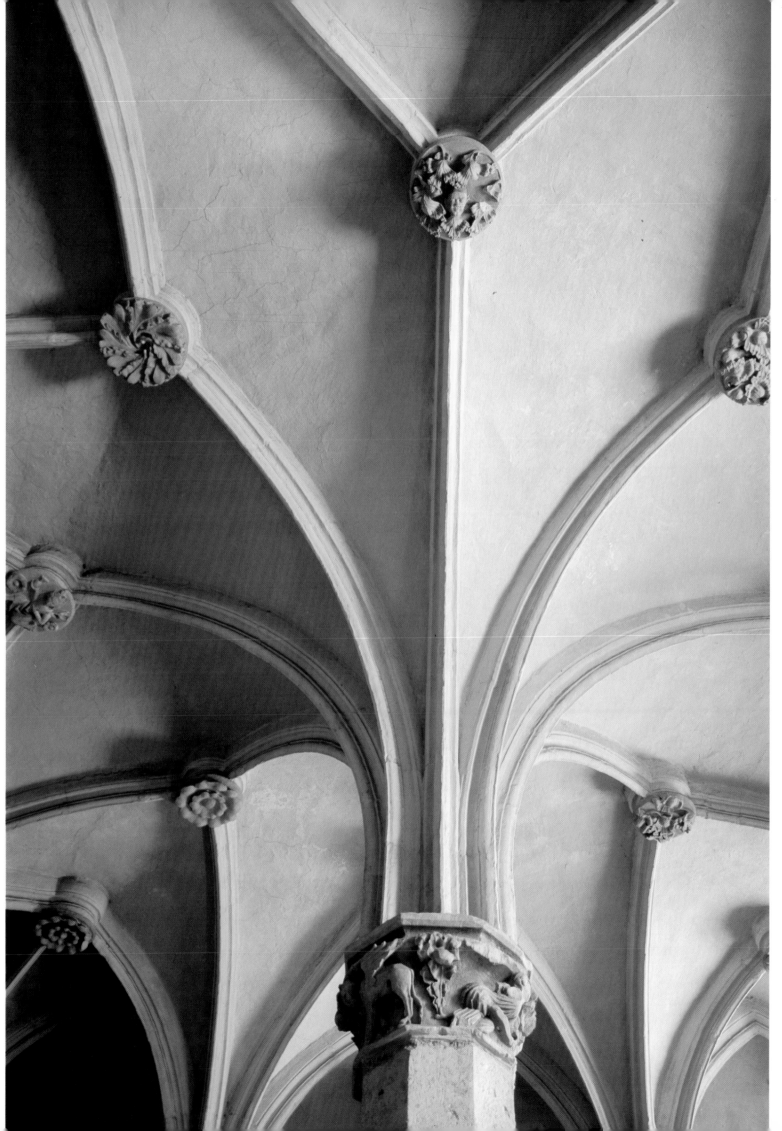

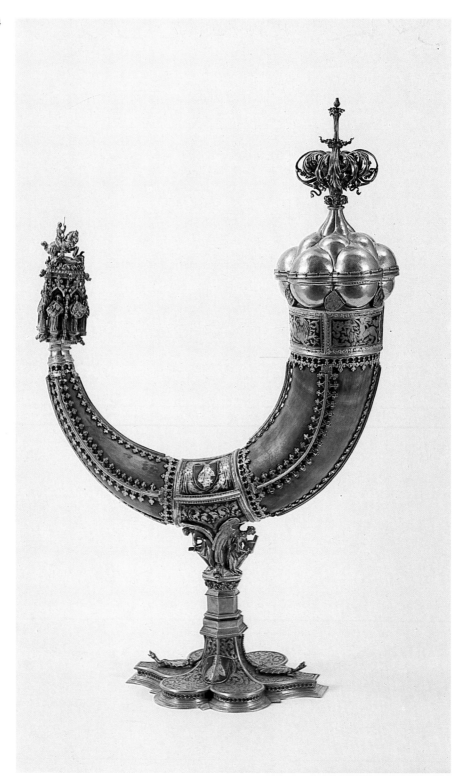

22. János Aquila: Christ on the Cross with Mary and
    John the Evangelist
    Fresco on th archway of the Velemér Church, 1377

23. Arches in the vestry of the former Franciscan
    Church of Szécsény
    Third quarter of the 14th century

24. Horn goblet with the coat-of-arms
of King Sigismund and Archbishop
György Palóczi of Esztergom, 1400–1450
Horn
Main Cathedral Treasury, Esztergom

25. The Matthias Calvary
Top: 1402; bottom: c. 1469–1490
Gold with precious stones and pearls
Main Cathedral Treasury, Esztergom

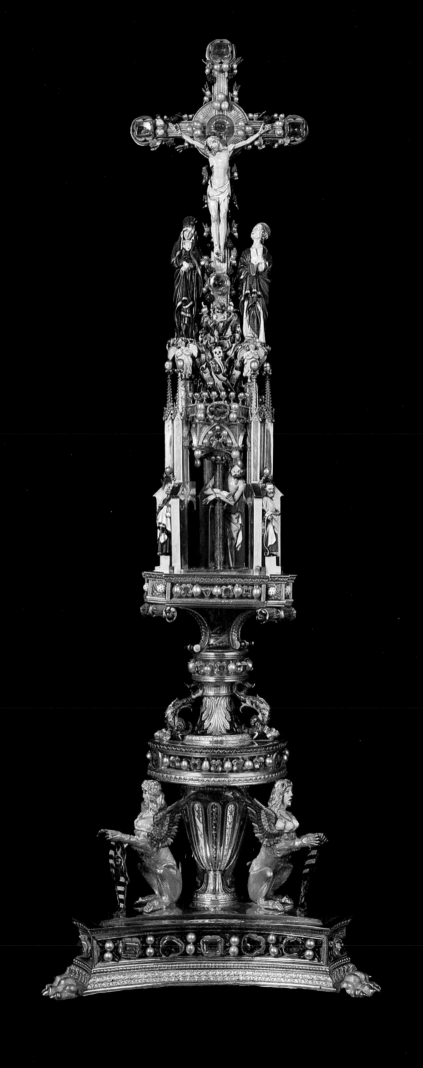

26

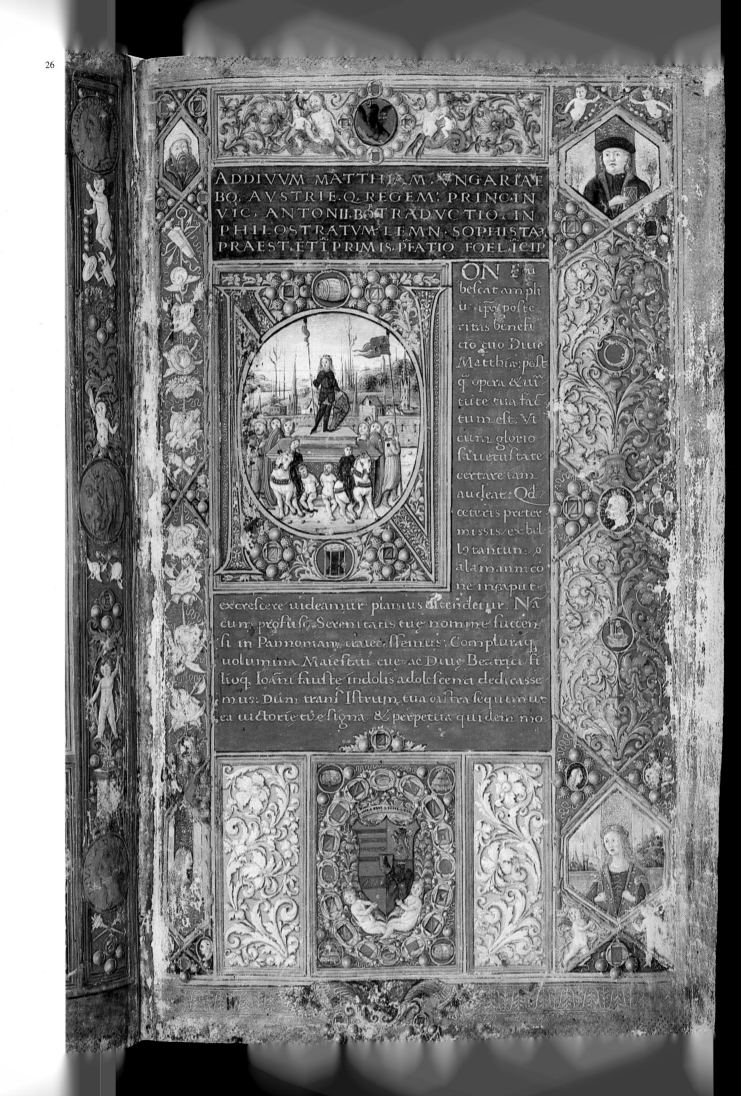

ADDIVVM MATTHIAM VNGARIAE
BO. AVSTRIE Q. REGEM: PRINCIN
VIC. ANTONII BO TRADVCTIO. IN
PHILOSTRATVM LEMN. SOPHISTA
PRAEST. ETI PRIMIS. PFATIO FOELICIP

ON Fu
bescat ampli
u ipsq pos te
ritas benefi
cio tuo Diue
Matthia: pos
q opera &uir
tute tua fac
tum est. Vt
cum glorio
sa uetustate
certare iam
audeat: Qd
ceteris preter
missis ex bel
lo tantun q
a la manu co
ne incaput

excrescere uideamur planius attendetur. Na
cum profusi Serenitatis tue nomine succen
si in Pannoniam traiecissemus: Compluraq
uolumina Maiestati tue ac Diue Beatrici fi
lioq Ioani fauste indolis adolescenti dedicasse
mus: Dum trans Istrum tua castra sequimur
ea uictorie tue signa & perpetua quidem mo

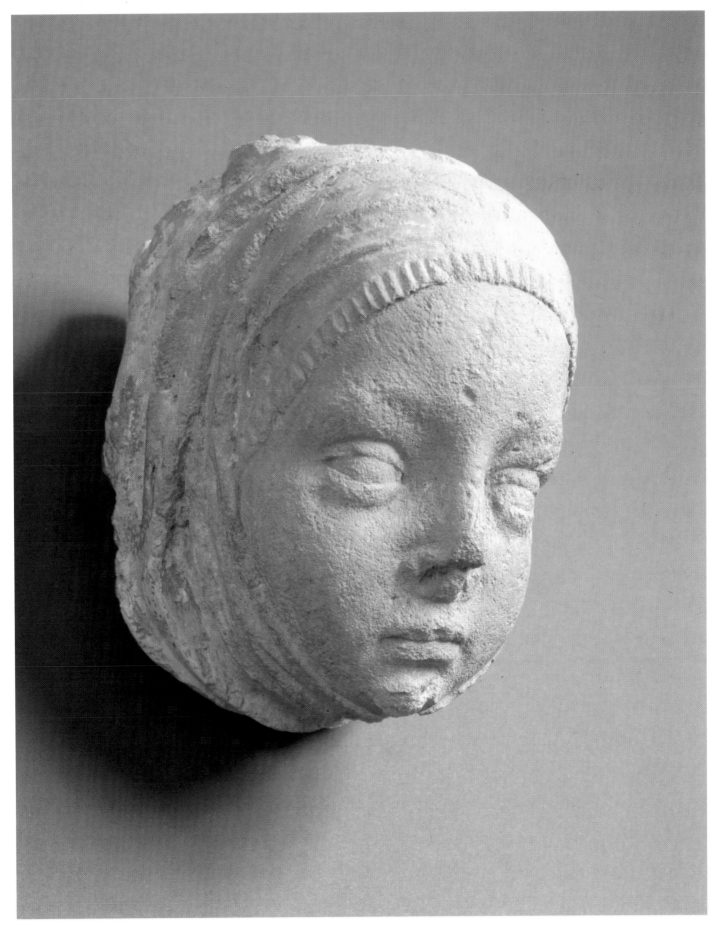

**26.** Boccardio Vecchio: Cover
of the Philostratus Codex, 1487–1490
Széchényi Library, Budapest

**27.** Girl's head from the Castle of Buda
First third of the 15th century
Limestone
Historical Museum of Budapest, Budapest

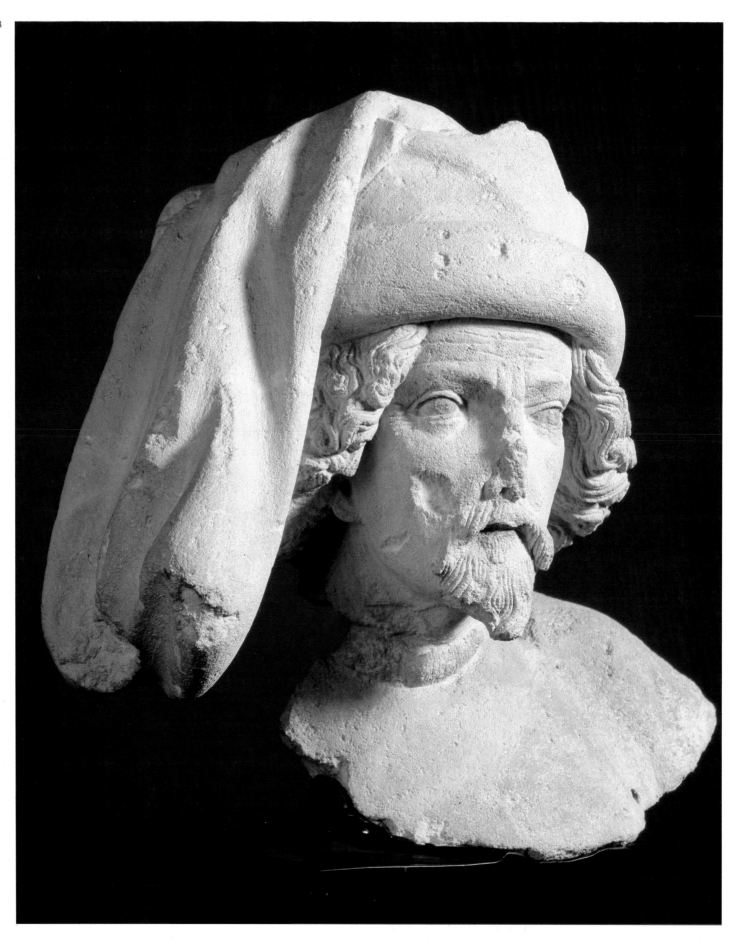

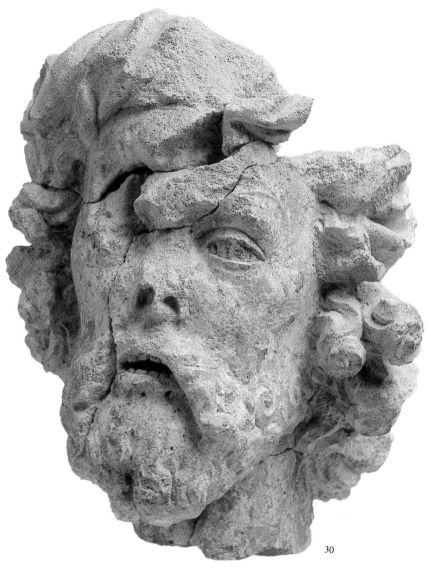

30

28. Knight from the Castle of Buda
First third of the 15th century
Limestone
Historical Museum of Budapest, Budapest

29. Apostle from the Castle of Buda
First third of the 15th century
Limestone with traces of paint
Historical Museum of Budapest, Budapest

30. Man's head from the Castle of Buda
First third of the 15th century
Limestone with traces of paint
Historical Museum of Budapest, Budapest

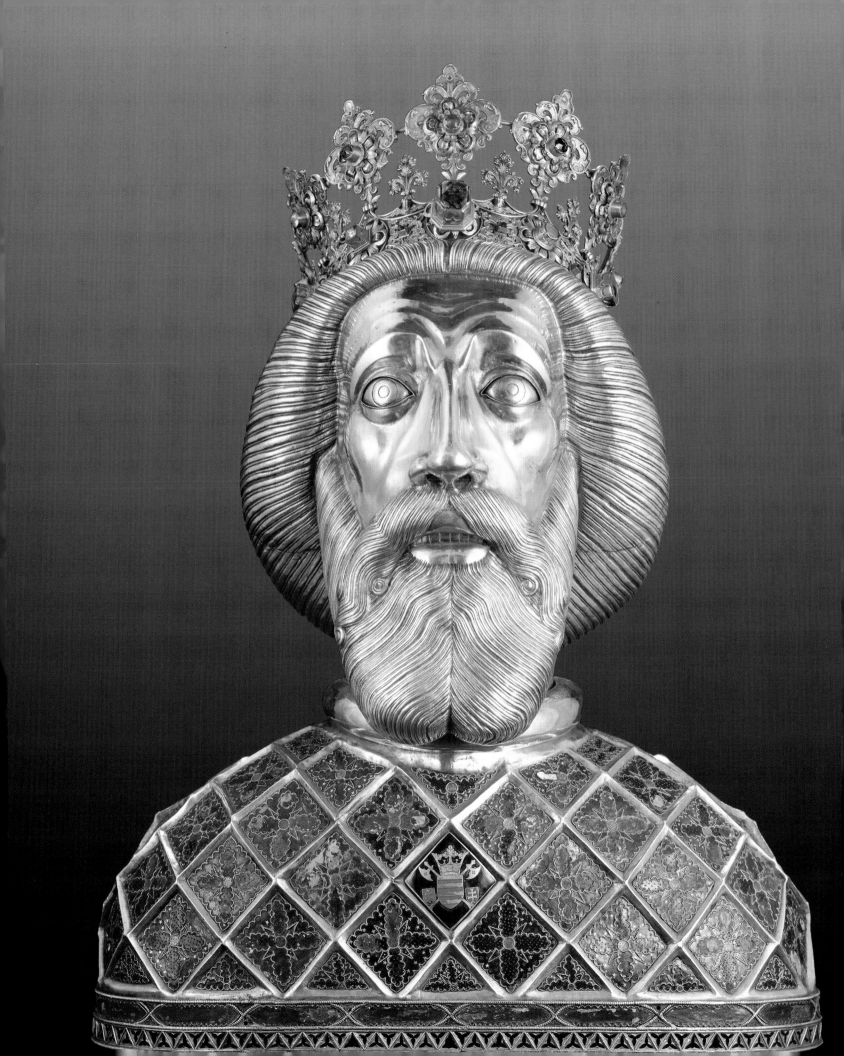

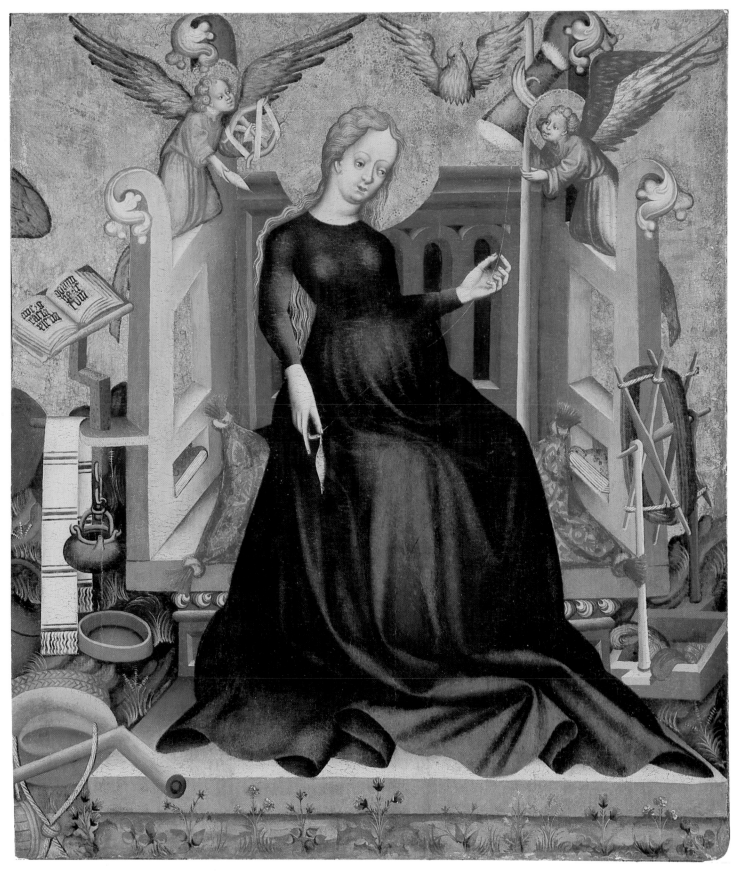

**31.** Reliquary of King Saint Ladislas, from Nagyvárad
First quarter of the 15th century
Gold plated silver
Cathedral Treasury, Győr

**32.** The Annunciation from Németújvár
Second quarter of the 15th century
Tempera on wood
Hungarian National Gallery, Budapest

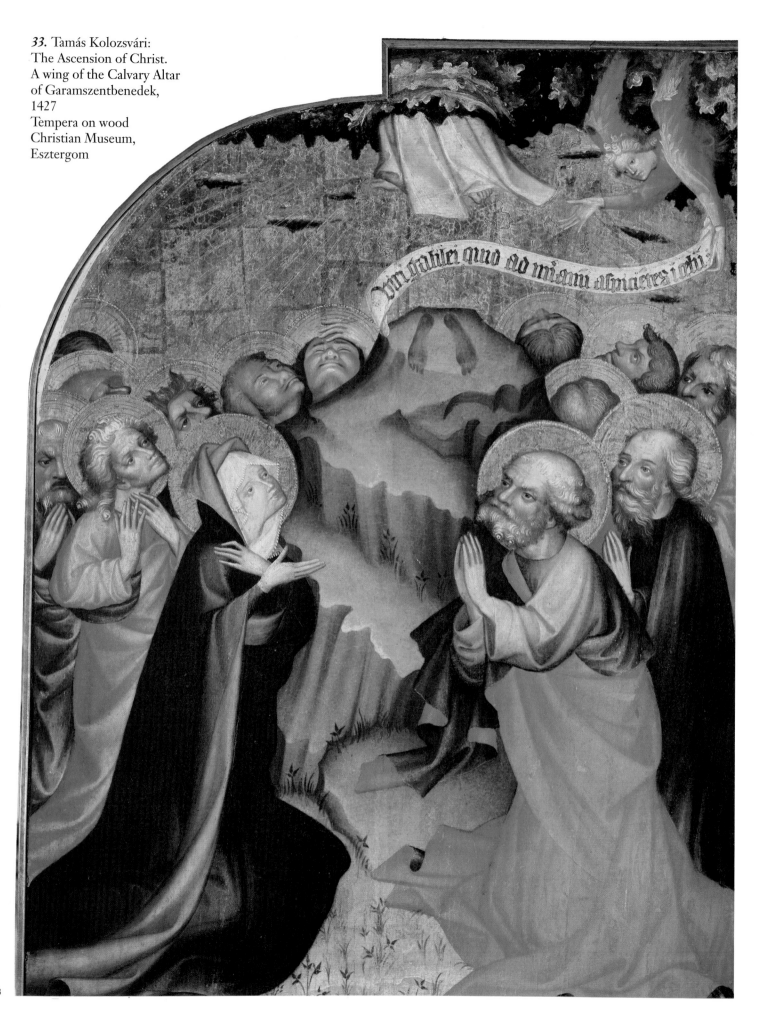

**33.** Tamás Kolozsvári:
The Ascension of Christ.
A wing of the Calvary Altar
of Garamszentbenedek,
1427
Tempera on wood
Christian Museum,
Esztergom

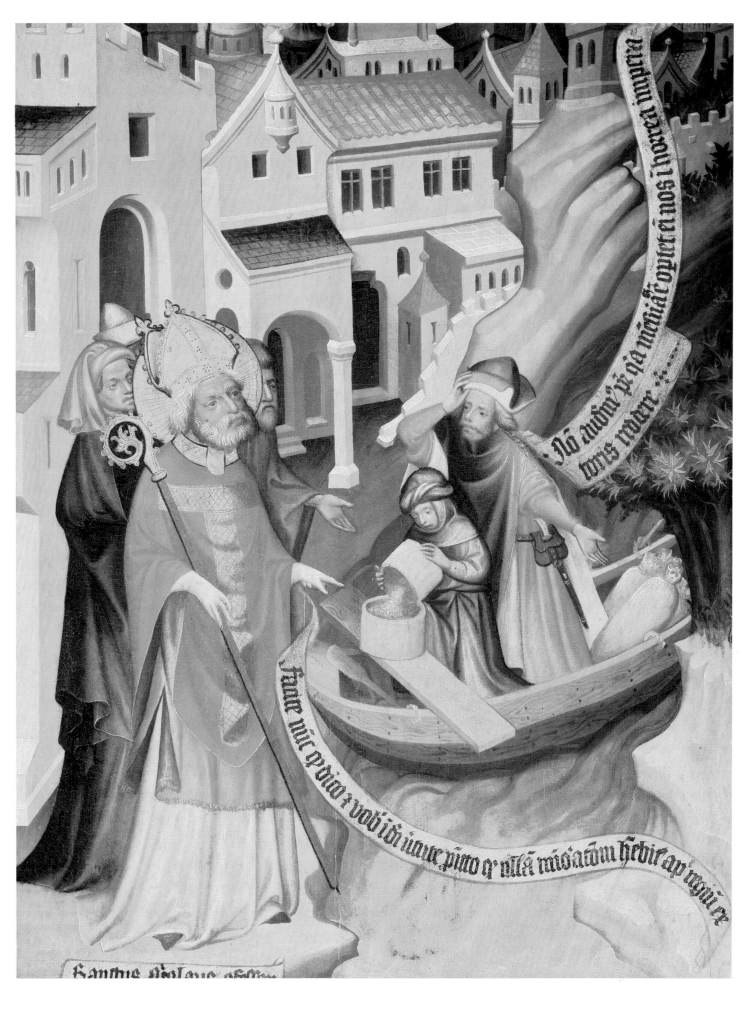

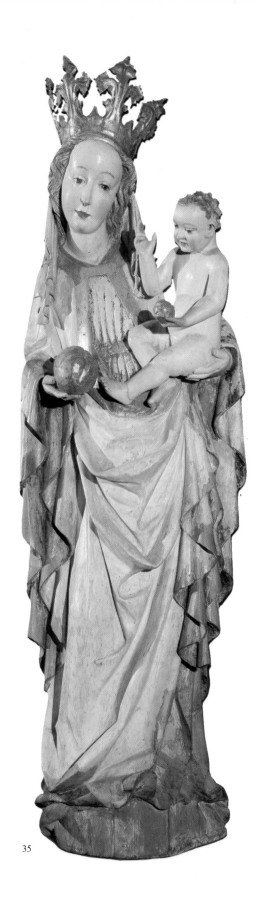

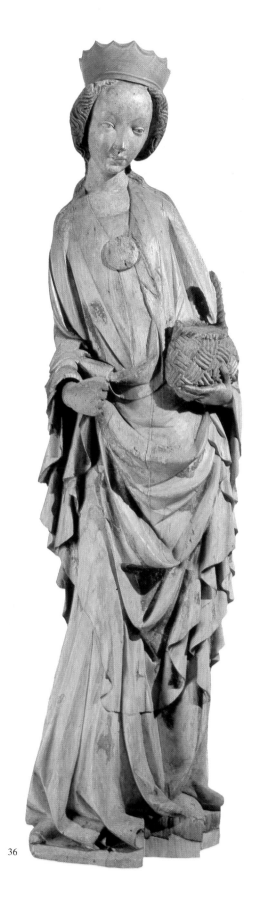

◁ **34.** Tamás Kolozsvári: The Miracle of the Wheat
of St. Nicholas of Myra, Garamszentbenedek, 1427
Tempera on wood
Christian Museum, Esztergom

**35.** Madonna II. from Toporc, c. 1420–1430
Painted linden wood
Hungarian National Gallery, Budapest

**36.** St. Dorothy from Barka, c. 1410–1420
Linden wood with traces of paint
Hungarian National Gallery, Budapest

**37.** The Lord's coffin from Garamszentbenedek,
c. 1480
Painted wood
Christian Museum, Esztergom

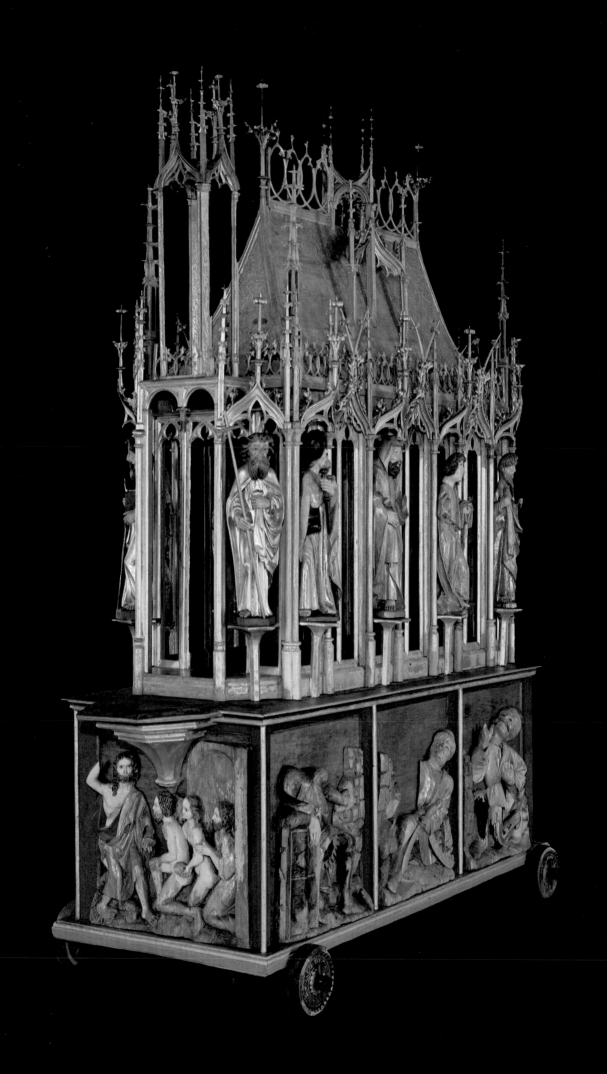

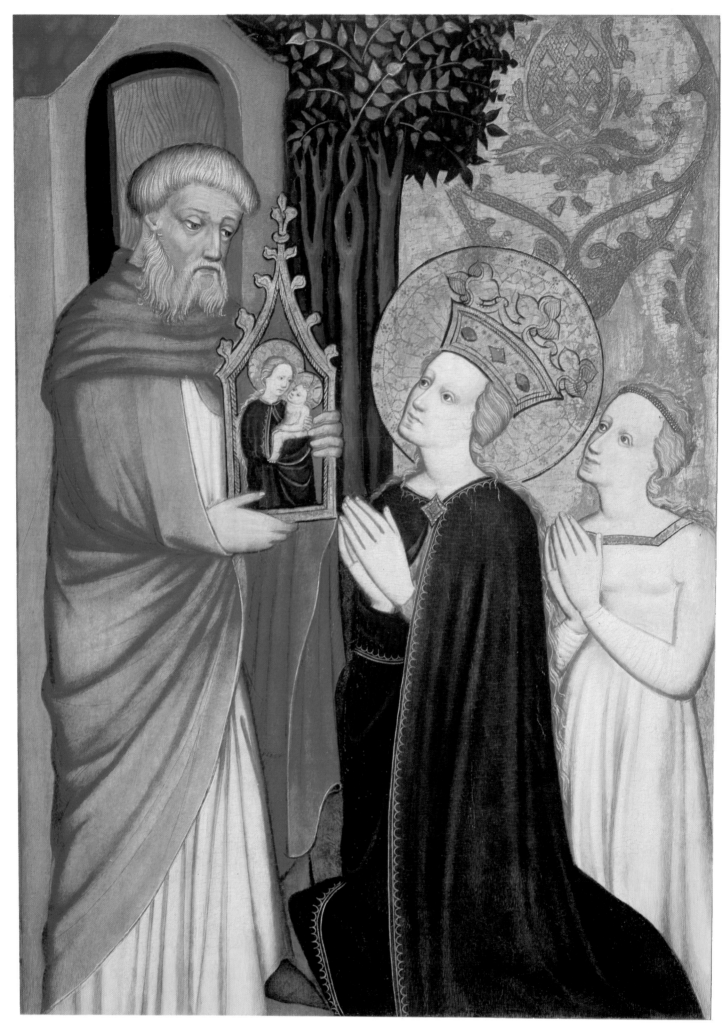

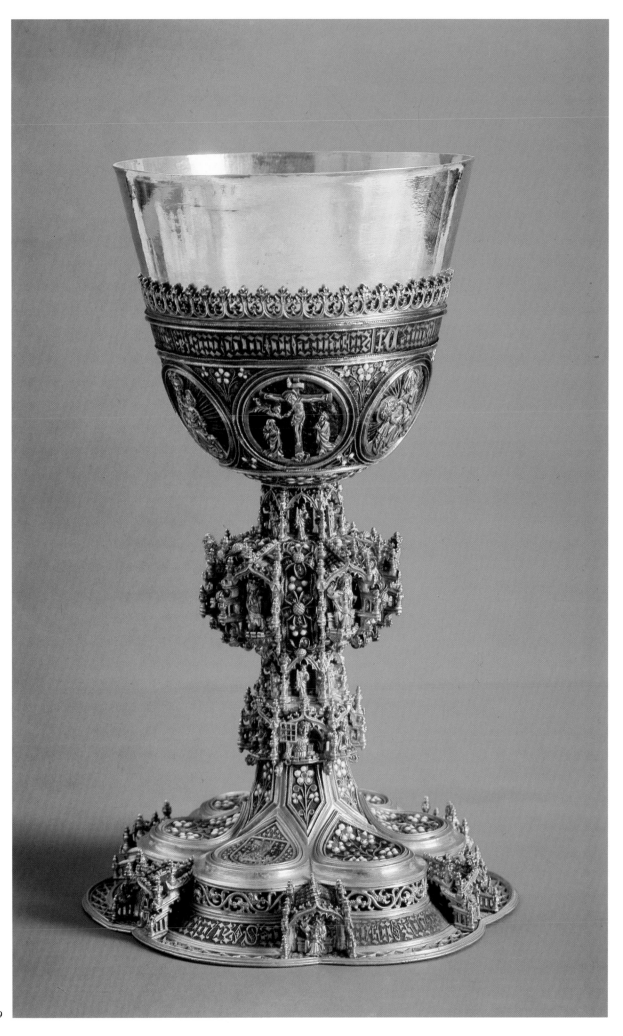

**38.** Scene from the Legend
of St. Catherine
of Alexandria
Altar from Bát, c. 1420
Tempera on wood
Christian Museum,
Esztergom

**39.** Goblet
of Benedek Suky, c. 1440
Gold plated silver
Main Cathedral Treasury,
Esztergom

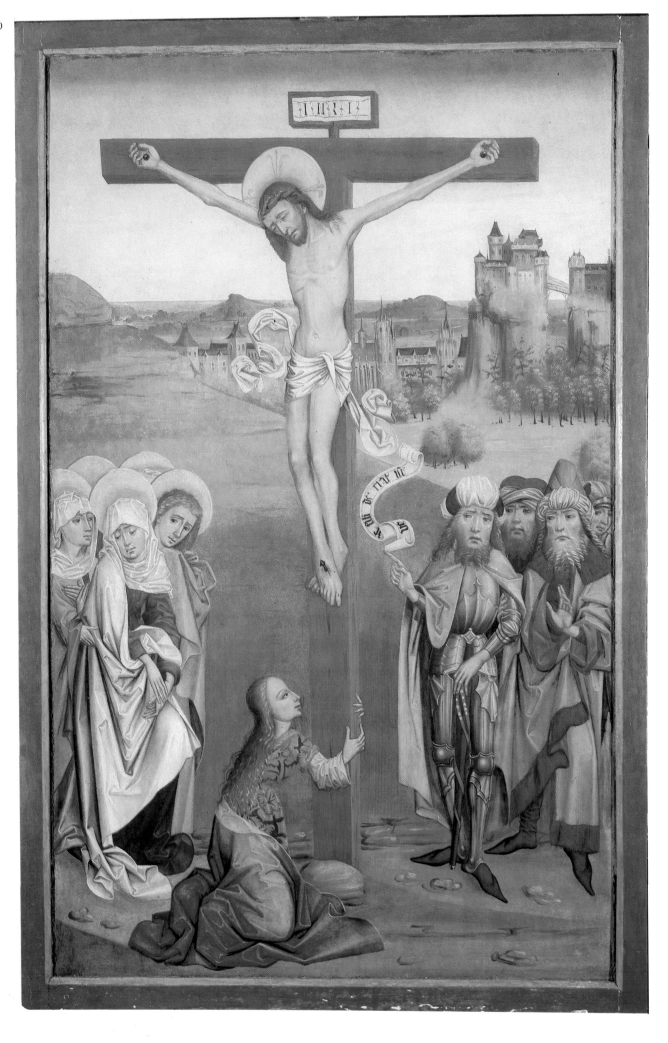

**40.** Crucifixion. Main tablet of the St. Miklós Altar
of Jánosrét, c. 1476
Tempera on wood
Hungarian National Gallery, Budapest

**41.** Virtues. Fresco from the study
of Vitéz János in the Castle of Esztergom, c. 1490's

**42.** Master M.S.: The Visitation ▷
Tempera on wood
Hungarian National Gallery, Budapest

**43.** Master M.S.: Crucifixion, 1506 ▷
Tempera on wood
Christian Museum, Esztergom

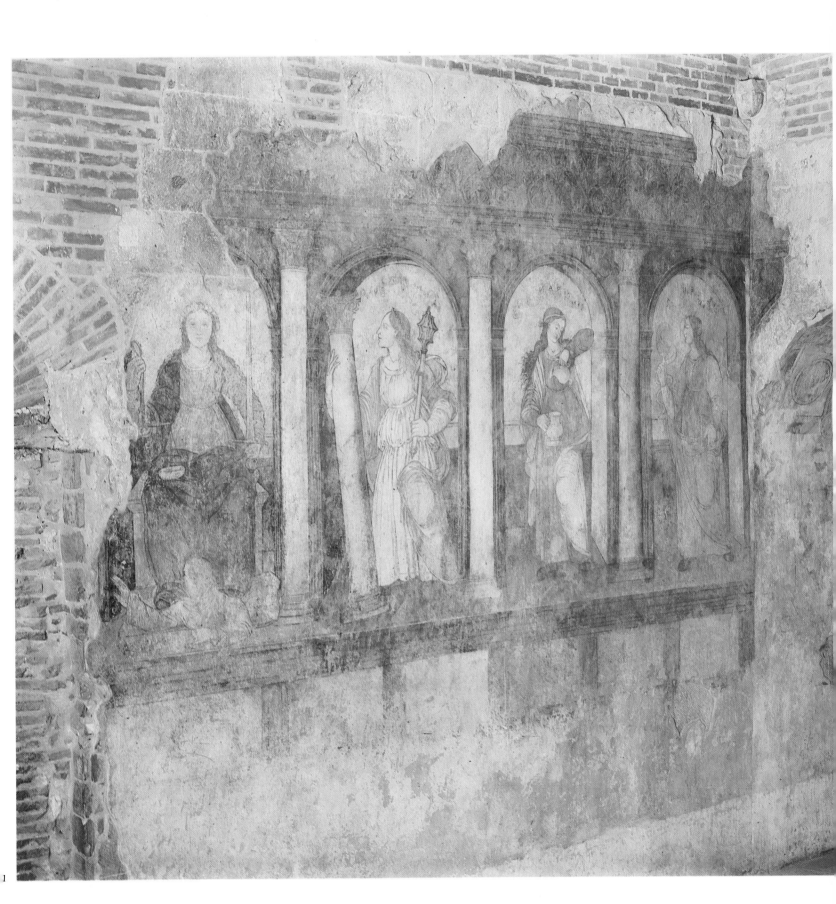

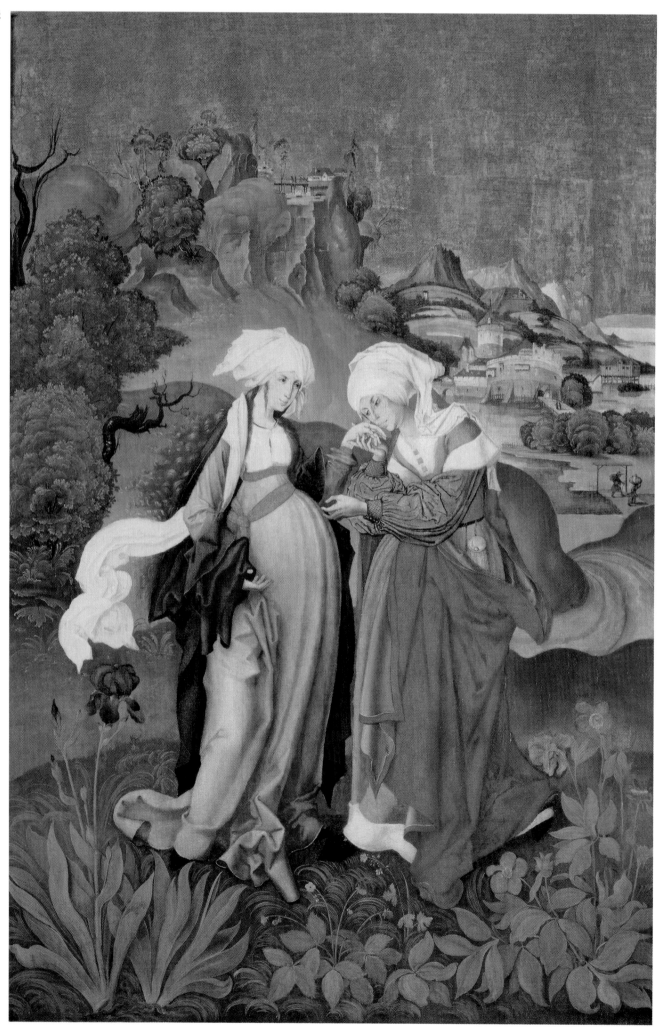

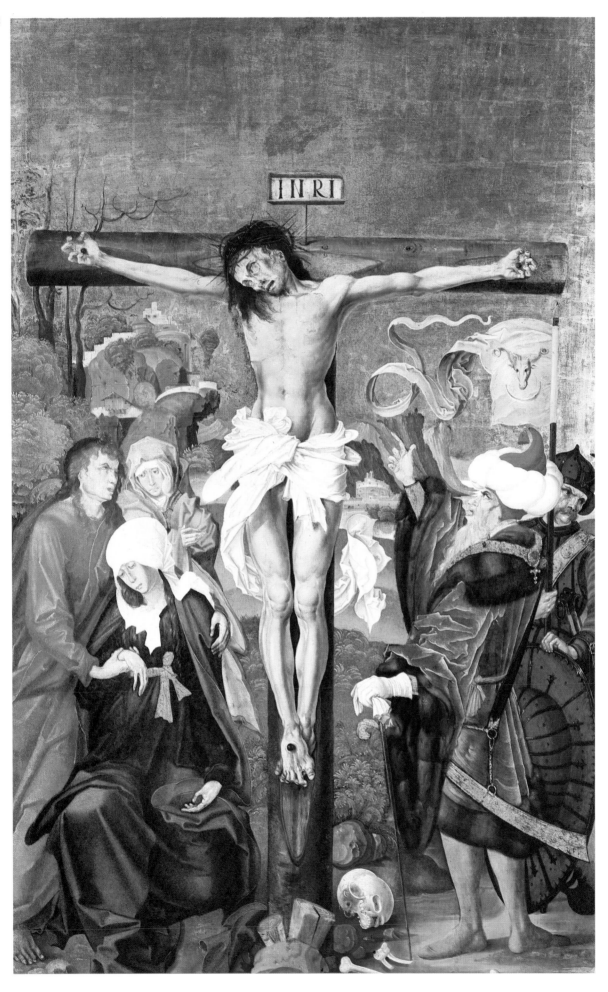

44

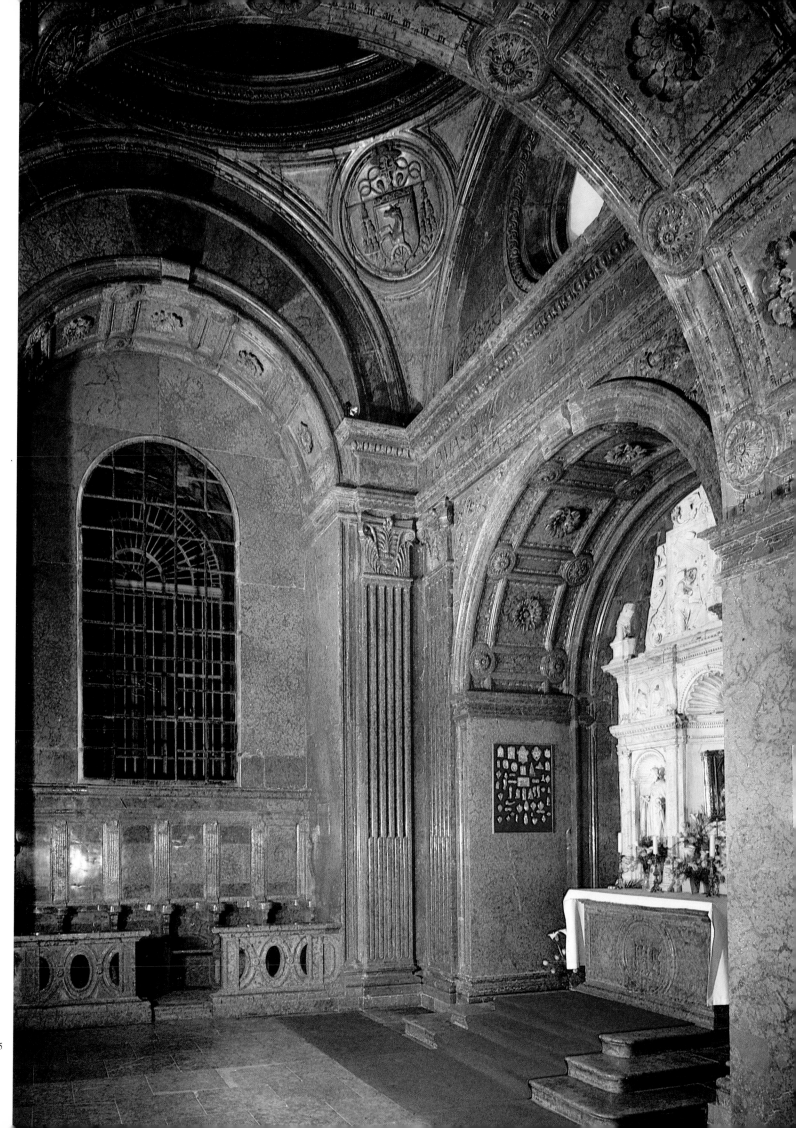

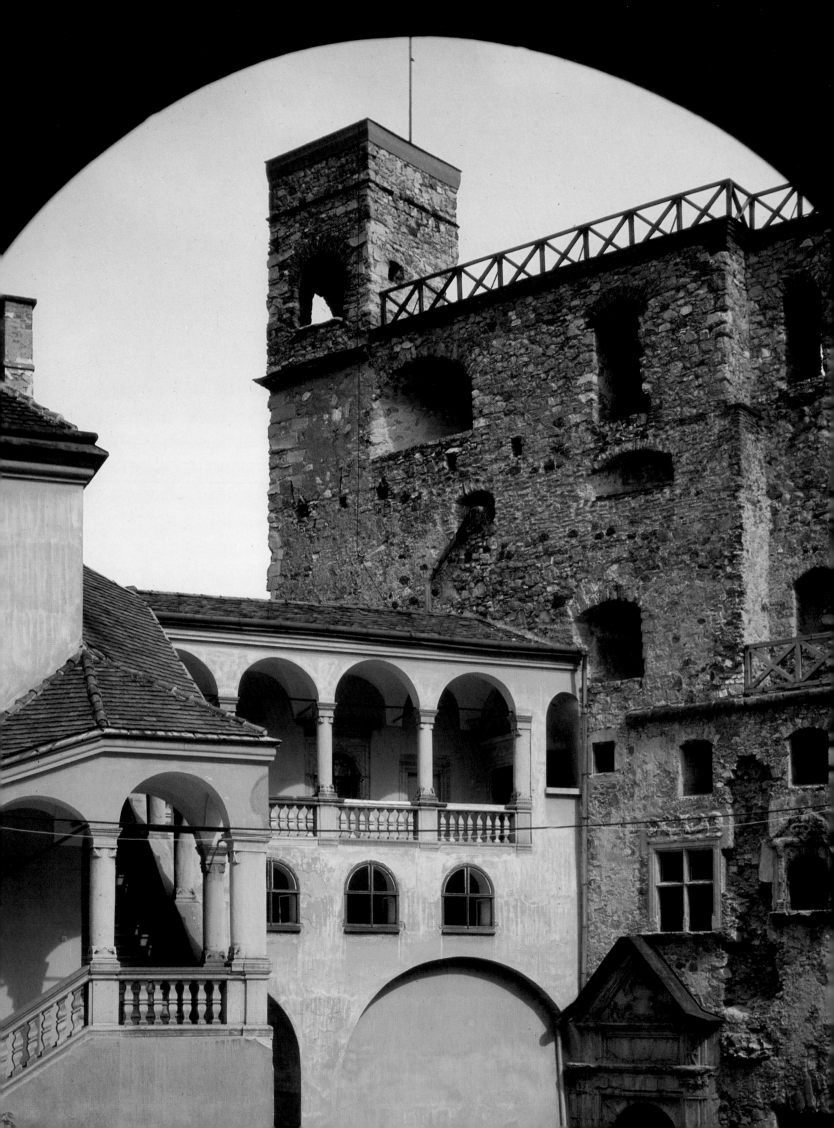

**46.** The Perényi Wing of the Castle of Sárospatak,
c. 1540–1563

**47.** Sgraffito-decorated residential house
on the Jurisics Square of Kőszeg, c. 1570

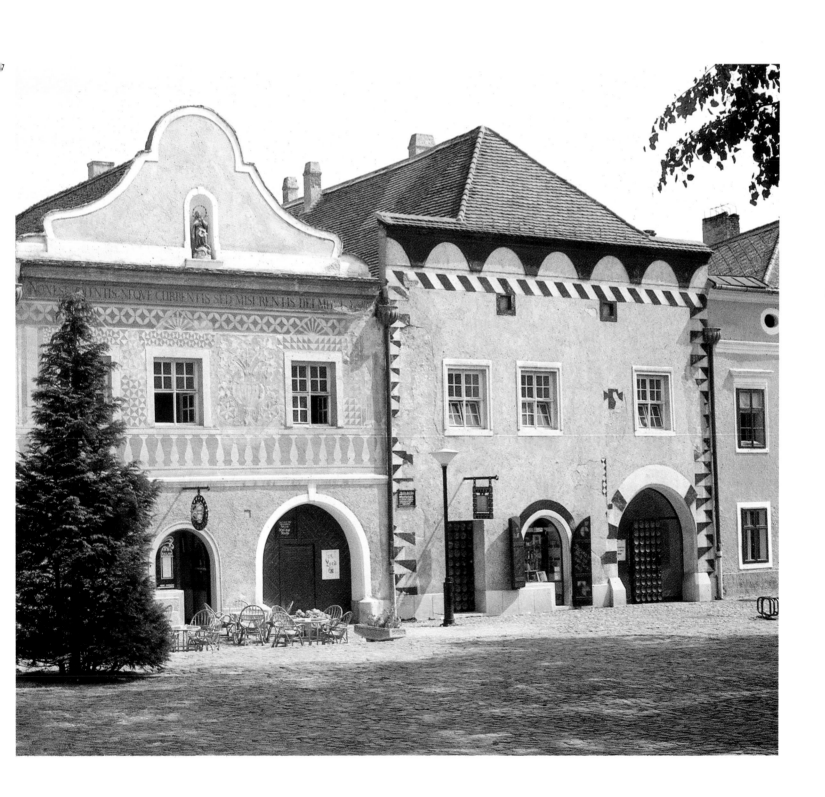

**48.** The Funeral Portrait of Mrs. Gáspár Illésházy, 1648
Oil on canvas
Hungarian National Gallery, Budapest

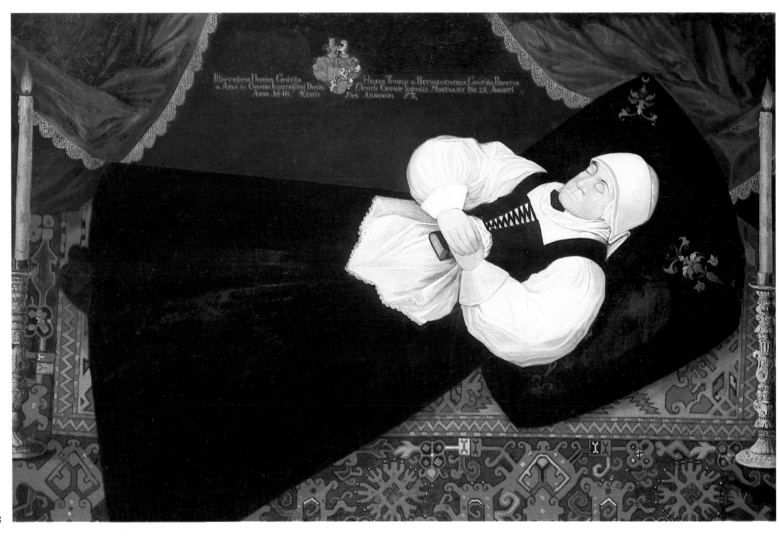

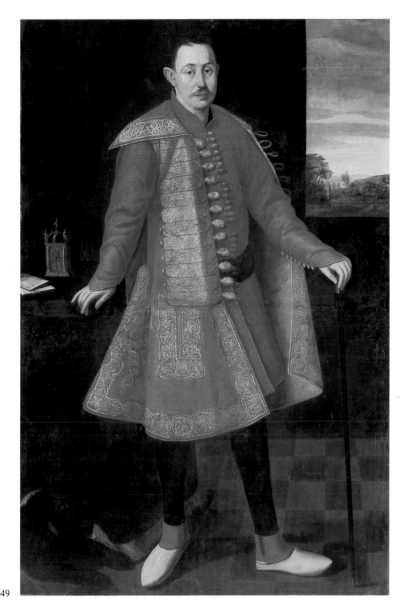

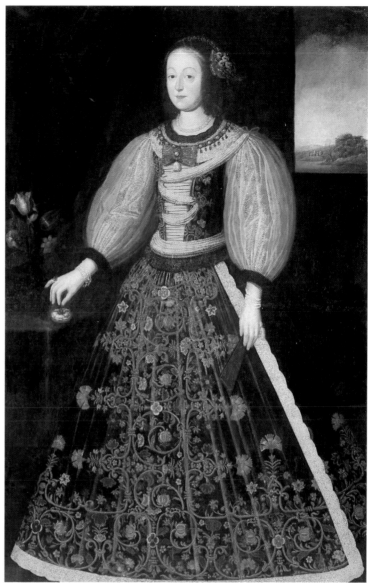

**49.** Benjamin Block: Portrait of Ferenc Nádasdy, 1656
Oil on canvas
Hungarian National Gallery, Budapest

**50.** Benjamin Block: Portrait of Mrs. Ferenc Nádasdy, 1656
Oil on canvas
Hungarian National Gallery, Budapest

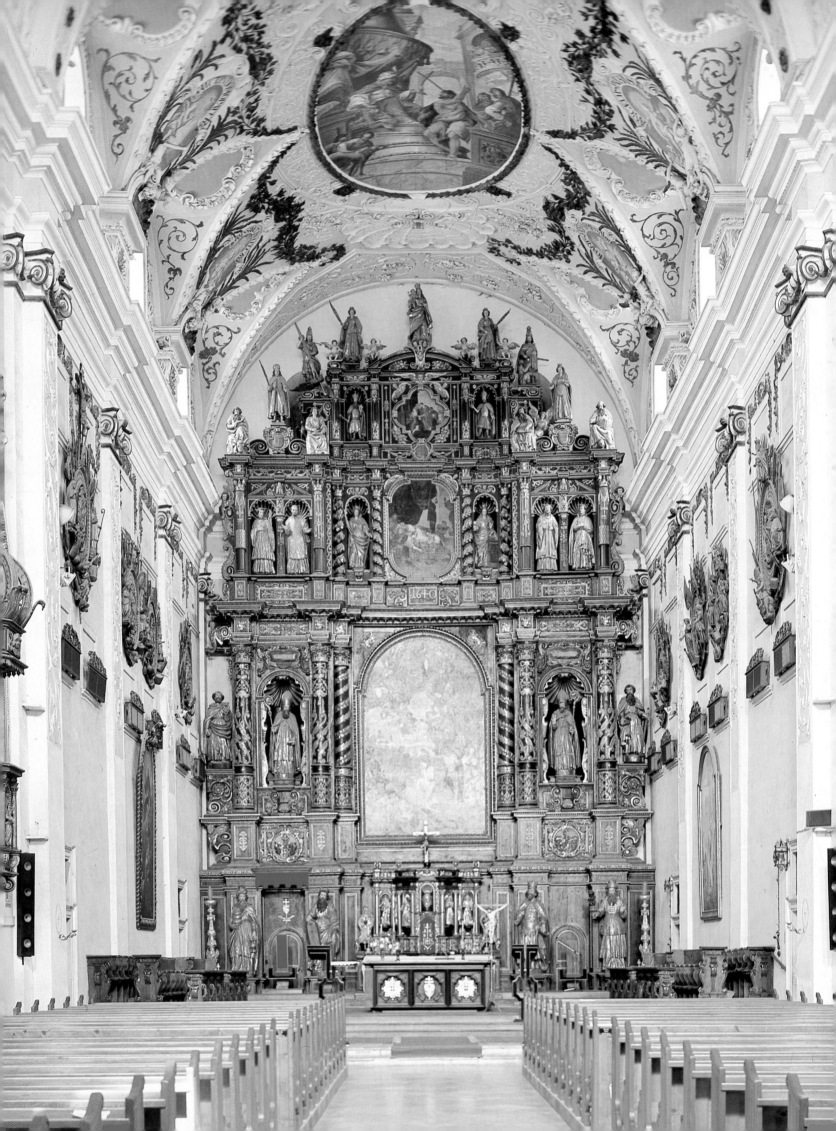

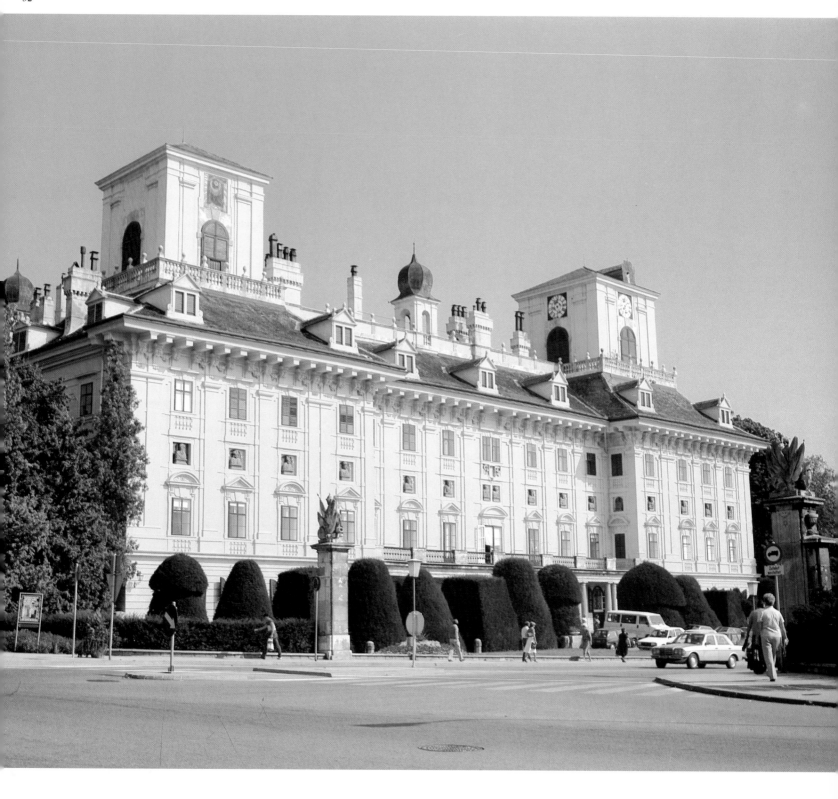

**51.** The main altar of the Jesuit Church in
Nagyszombat, 1640

**52.** The Esterházy Castle in Kismarton, 1660–1672
Built by Carlo Martino Carlone

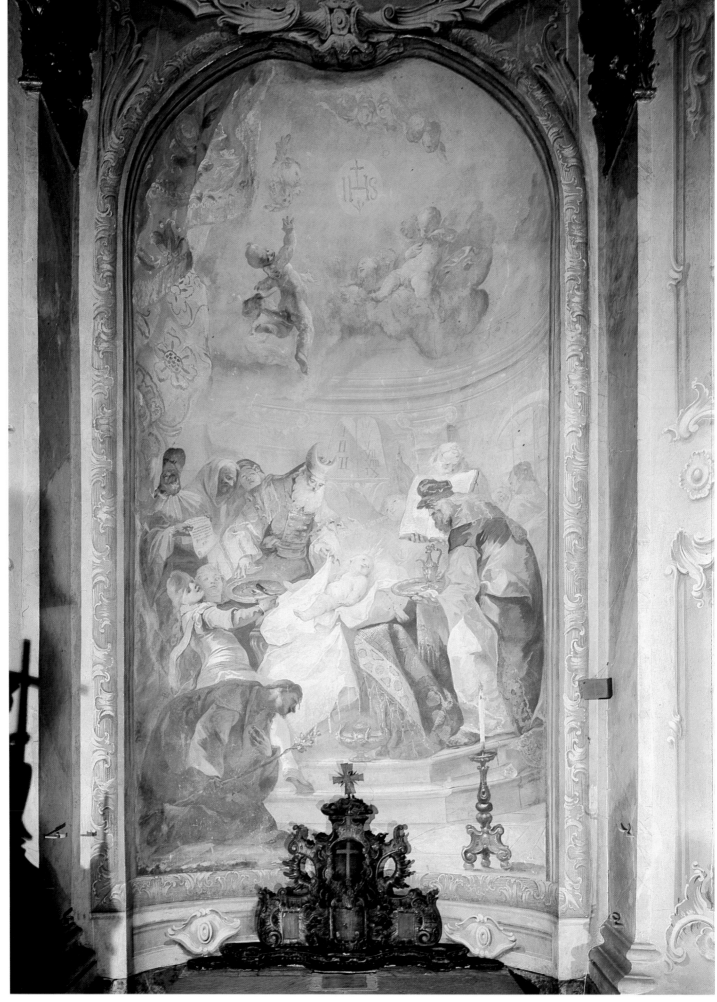

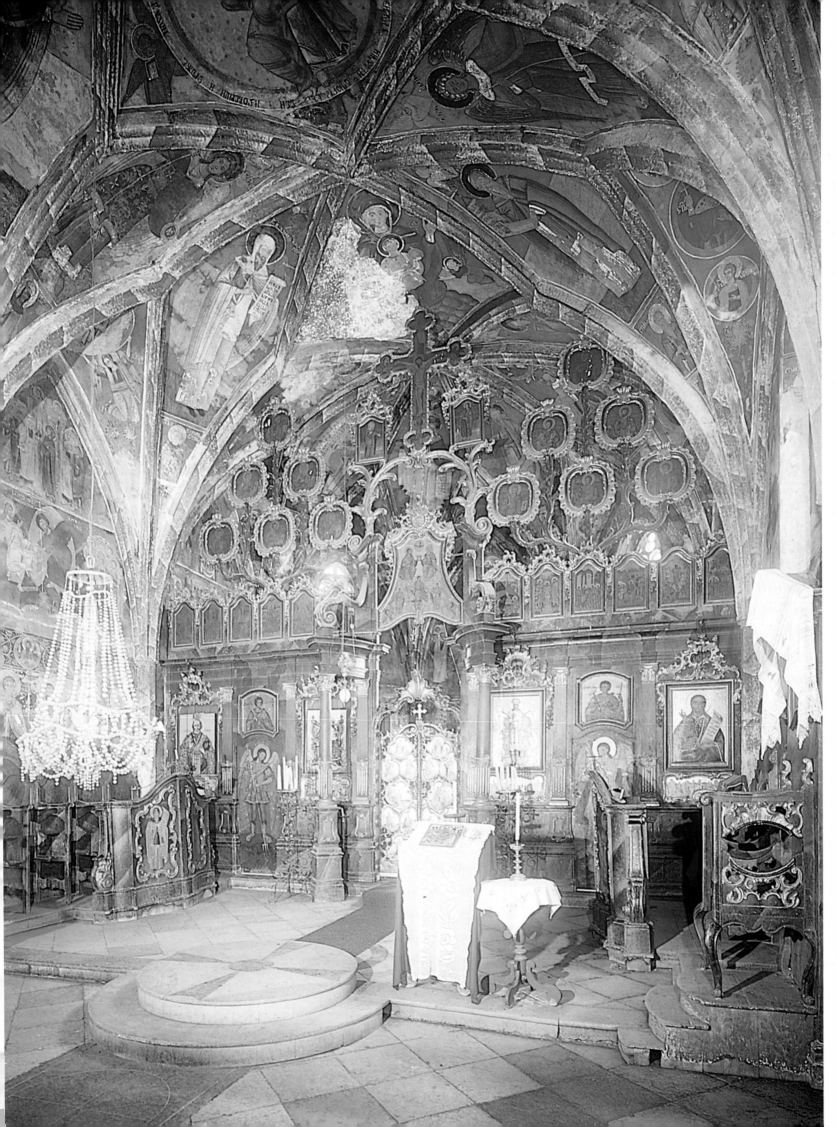

◁ **53.** Franz Anton Maulbertsch:
The Circumcision of Christ, 1758
Fresco from the Christ's Ascension Church
in Sümeg

◁ **54.** The Serbian Greek Orthodox Church
of Ráckeve
Erected in 1487
Wall paintings from 1771

55

**55.** The Esterházy Castle in Fertőd, after 1765

**56.** The façade of the Esterházy Castle in Fertőd, after 1765

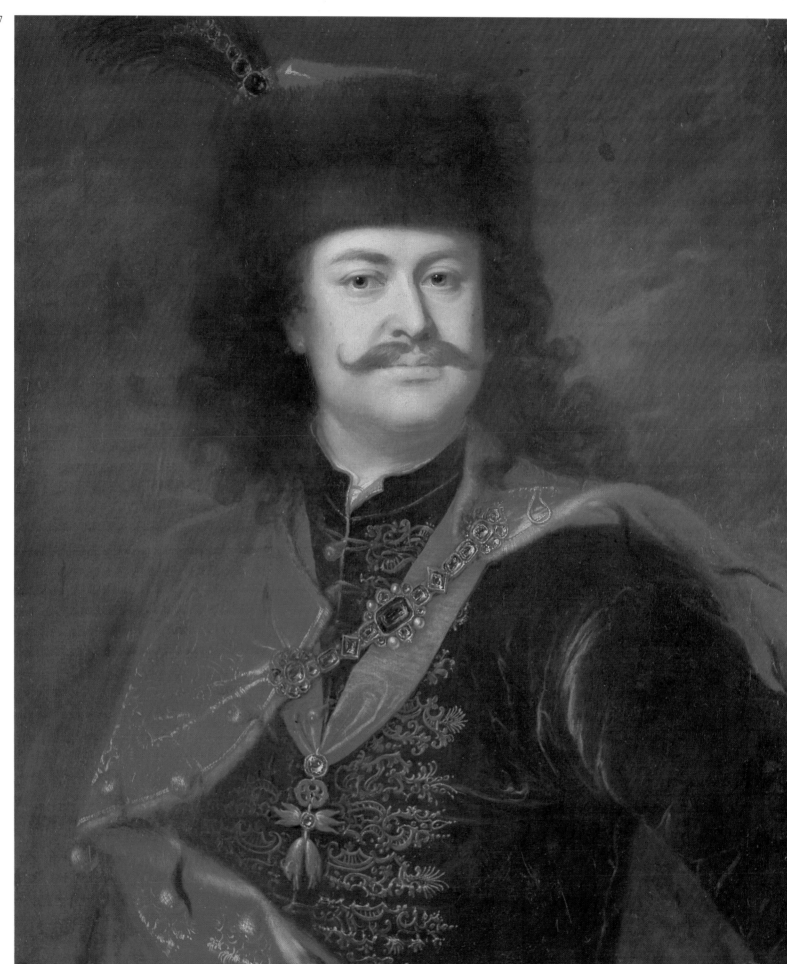

**57.** Ádám Mányoki: Portrait
of Ferenc Rákóczi II, 1724
Oil on canvas
Hungarian National Gallery, Budapest

**58.** The main façade of the Liceum
of Eger, from 1762
Built by Josef Ingaz Gerl

**59.** Johann Lucas Kracker:
The Council of Trident, 1781
Fresco in the library of the Liceum
of Eger

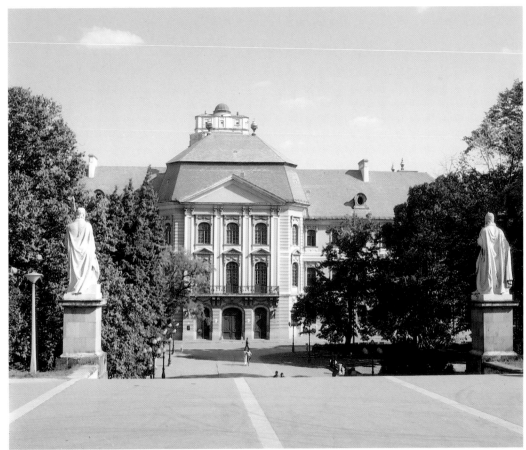

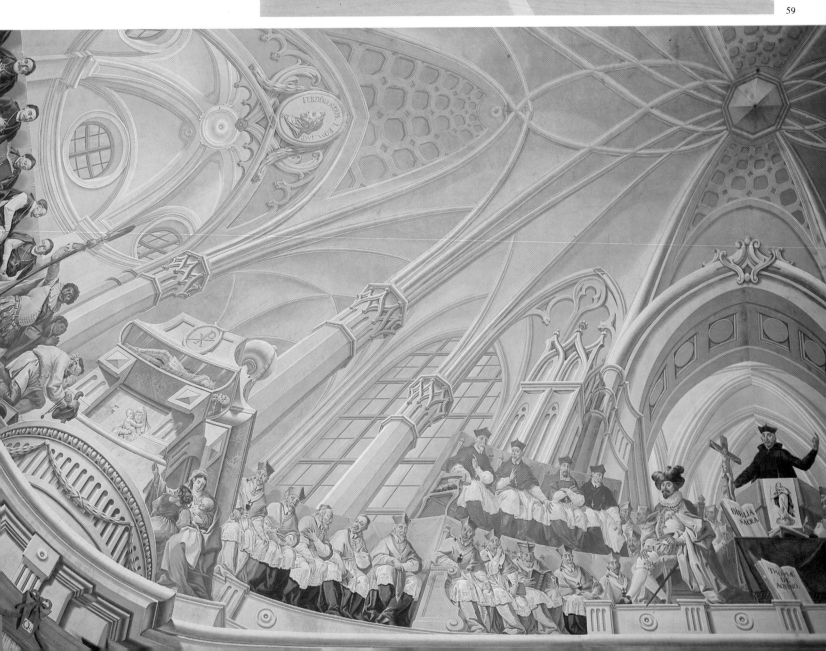

**60.** Philipp Jacob Straub (?): St. Roch from the altar of the former
Franciscan Church, 1757
Painted wood
Hungarian National Gallery, Budapest

**61.** Philipp Jacob Straub (?):
St. Sebastian from the altar of the former
Franciscan Church, 1757
Painted wood
Hungarian National Gallery, Budapest

**62.** Monstrance, 1752
Made by János Szilassy
Gold plated silver
Franciscan Church, Eger

60

61

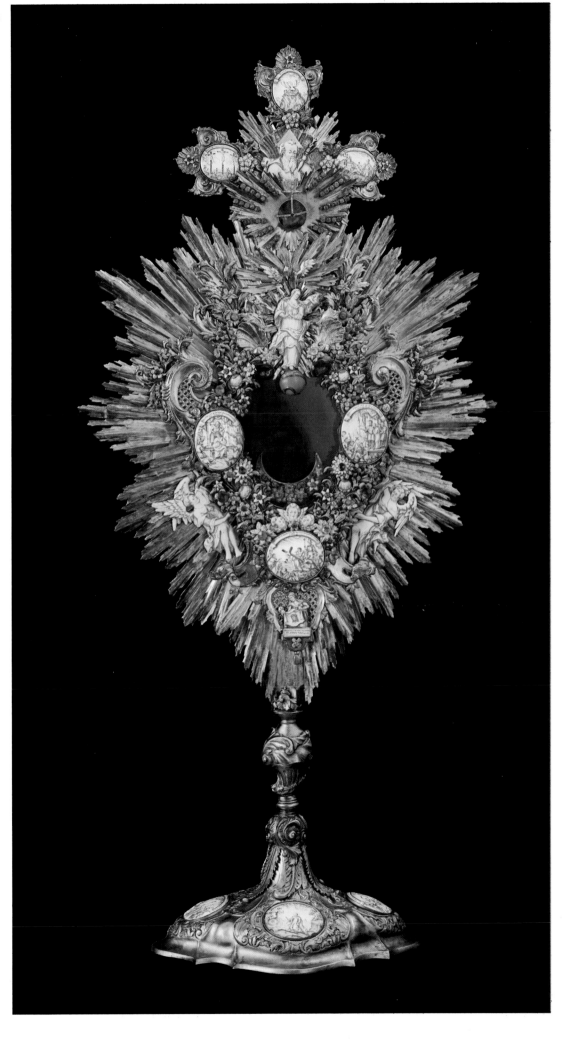

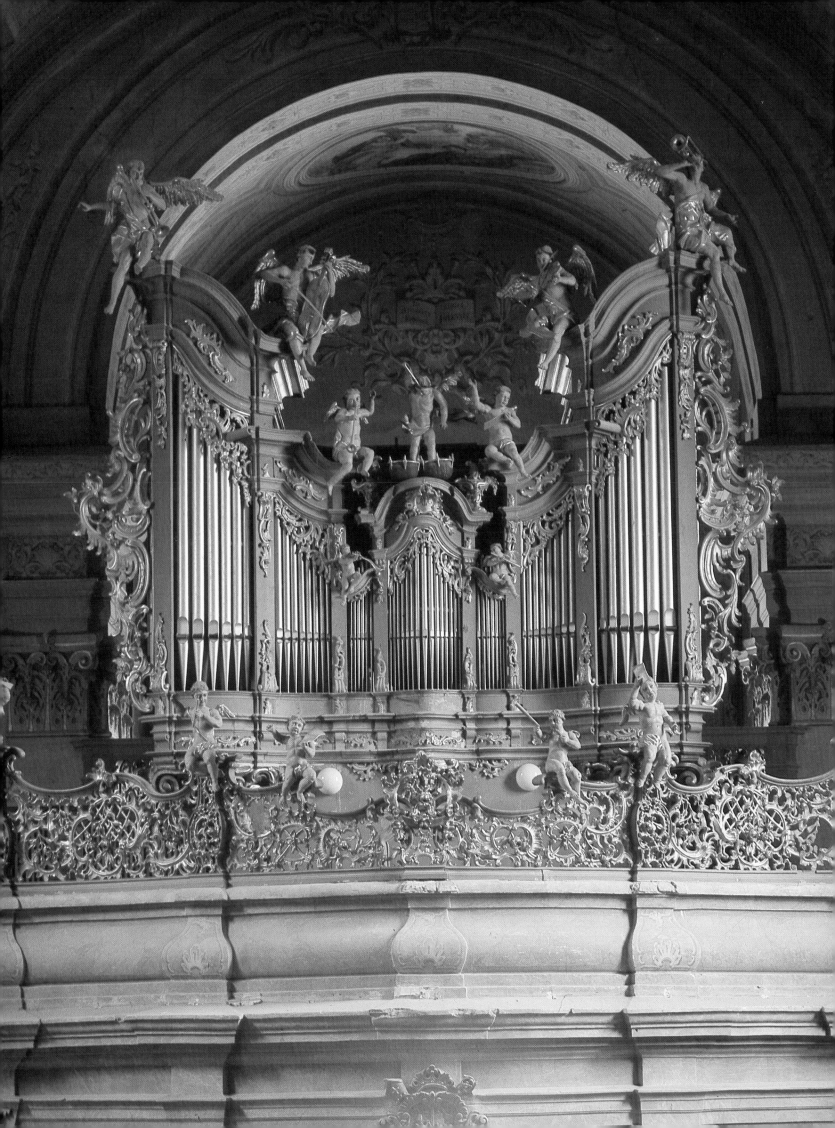

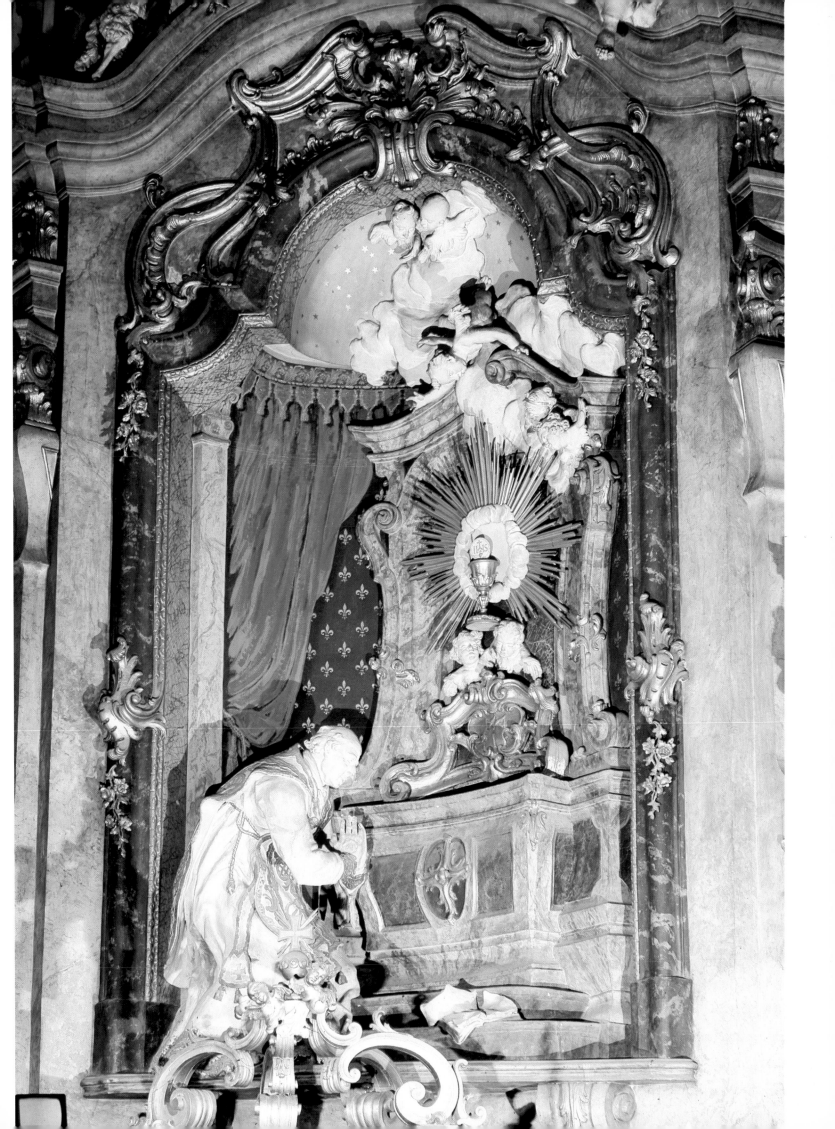

<◁ *63.* Sebestyén Stulhoff: Organ cabinet
and organ loft, 1760–1770
Former Benedictine Abbey Church,
Tihany

◁ *64.* Anton Krauss: St. Frances of Borgia,
1769–1770
The main altar of the former
Jesuit Church, Eger

65. János Rombauer: the English garden
of the Csáky Palace in Hotkóc, 1803
Oil on canvas
Hungarian National Gallery, Budapest

66. The painted paneled ceiling
of the Presbyterian Church
of Tákos. Late 18th century

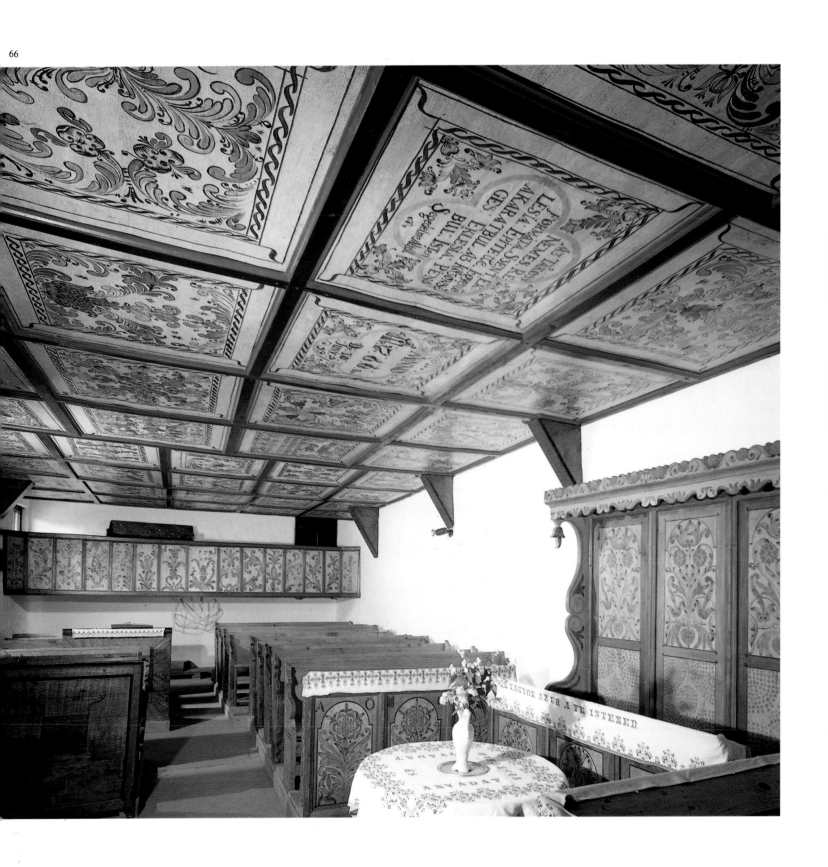

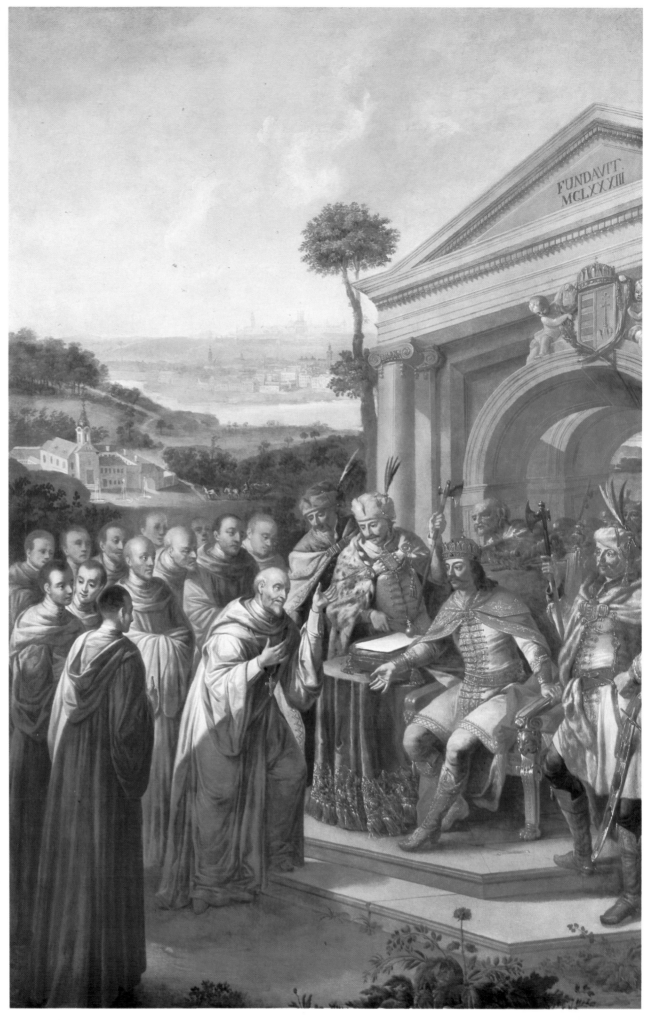

*67.* Stefan Dorfmeister: Béla III.
Founds the Szentgotthárd Monastery 1795–1796
Oil on canvas
Hungarian National Gallery, Budapest

*68.* Rudolf Alt: The National Museum, after 1838
Copper engraving

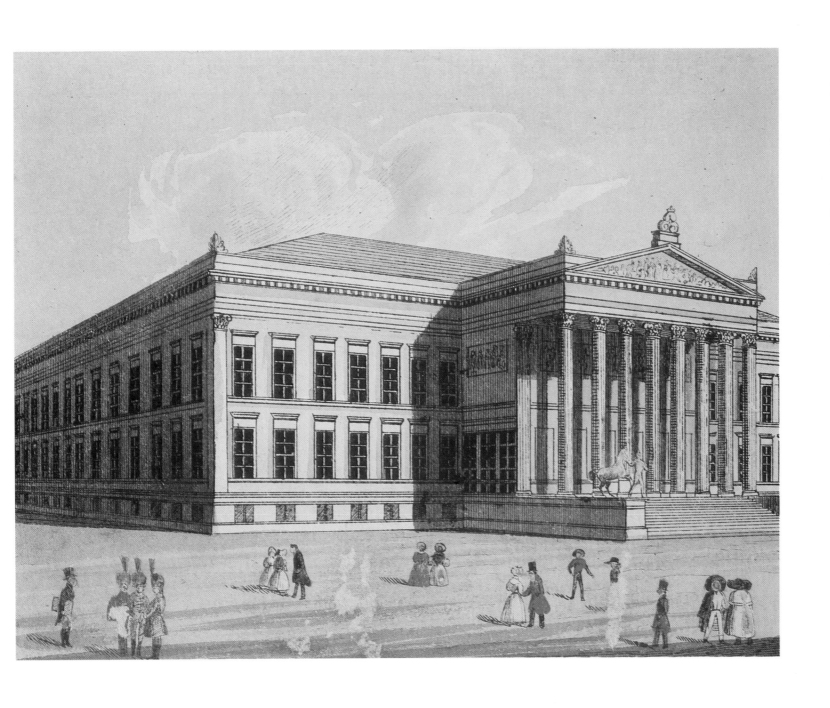

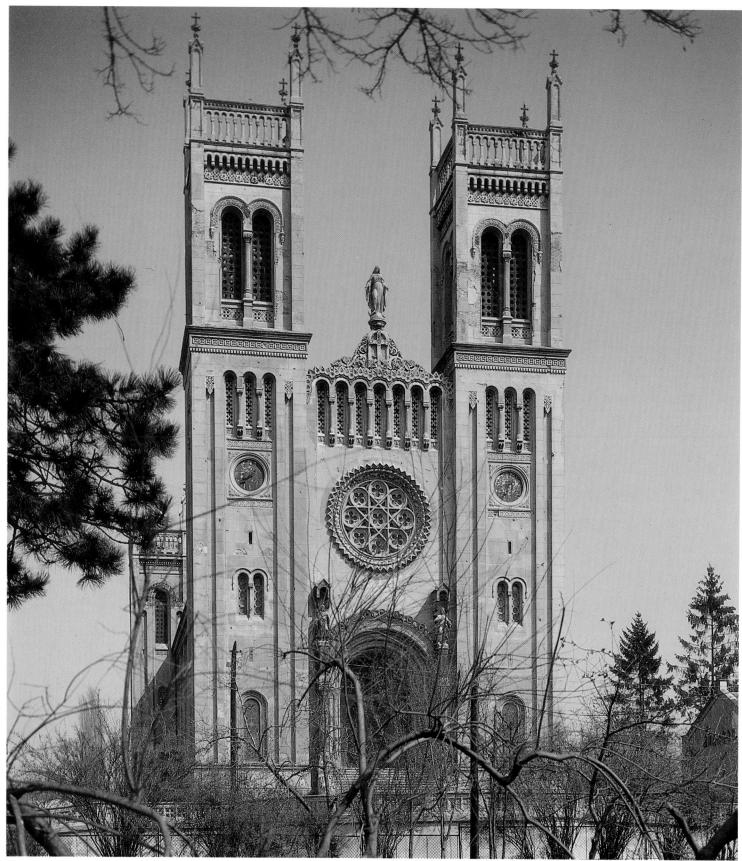

***69.*** The Church of King Saint Stephen, Fót
Built by Miklós Ybl, 1845–1855

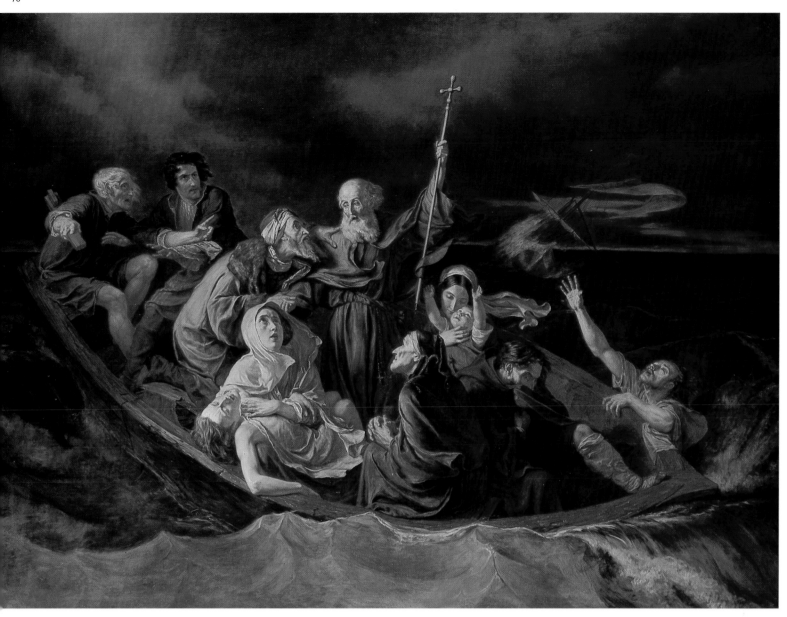

**70.** Mihály Zichy: Lifeboat, 1847
Oil on canvas
Hungarian National Gallery, Budapest

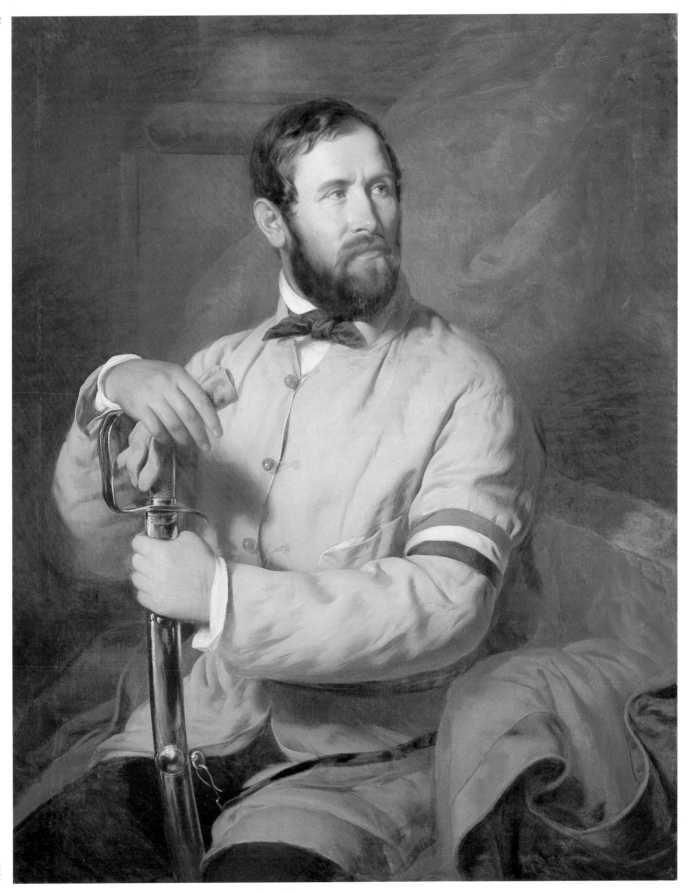

**71.** Miklós Barabás: Franz Liszt, 1847
Oil on canvas
Hungarian National Gallery, Budapest

**72.** József Borsos: National Guardsman, 1848
Oil on canvas
Hungarian National Gallery, Budapest

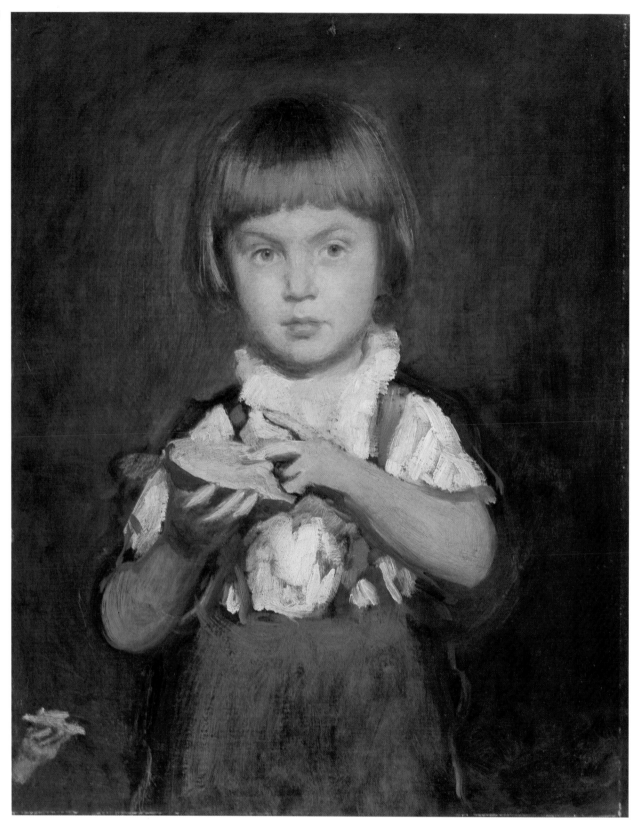

*73.* Bertalan Székely: Boy with Buttered Bread, c. 1875
Oil on canvas
Hungarian National Gallery, Budapest

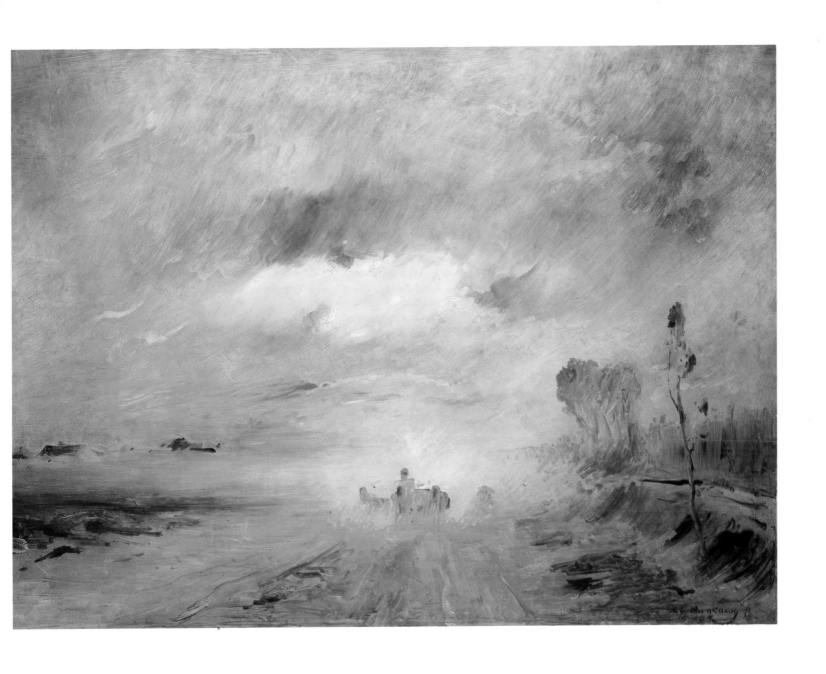

**74.** Mihály Munkácsy: Dusty Road, 1874
Oil on canvas
Hungarian National Gallery, Budapest

**75.** Pál Szinyei Merse: Couple in Love, 1870
Oil on canvas
Hungarian National Gallery, Budapest

75

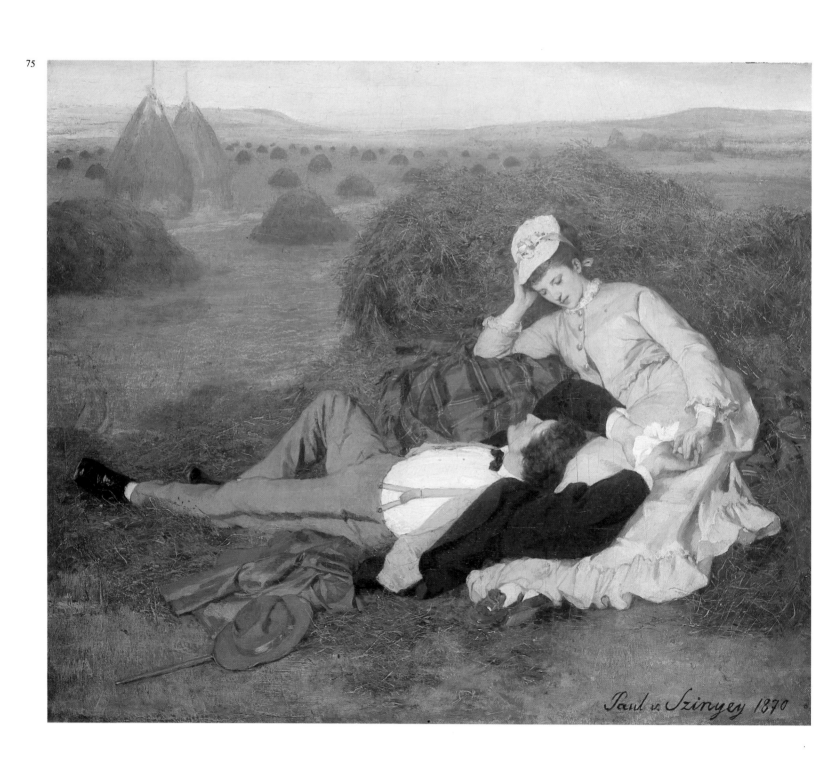

**75.** Pál Szinyei Merse: Couple in Love, 1870
Oil on canvas
Hungarian National Gallery, Budapest

Paul v. Szinyey 1870

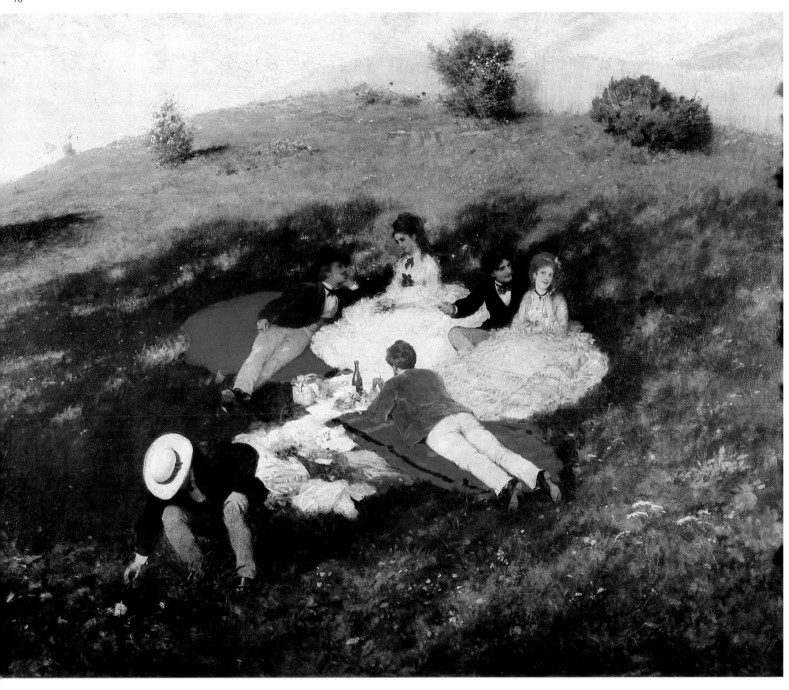

**76.** Pál Szinyei Merse: Mayfair, 1873
Oil on canvas
Hungarian National Gallery, Budapest

**77.** The Budapest Opera House, 1878–1884
Built by Miklós Ybl

**78.** The Parliament, 1883–1904
Built by Imre Steindl

**79.** Hero's Square, 1894–1928
Designed by Albert Schickedanz.
The Millennial Monument is the work
of György Zala

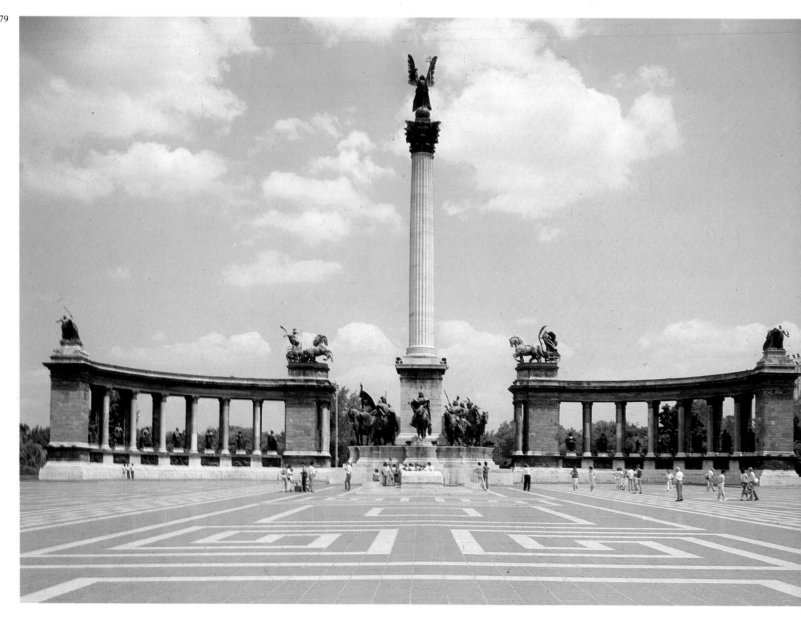

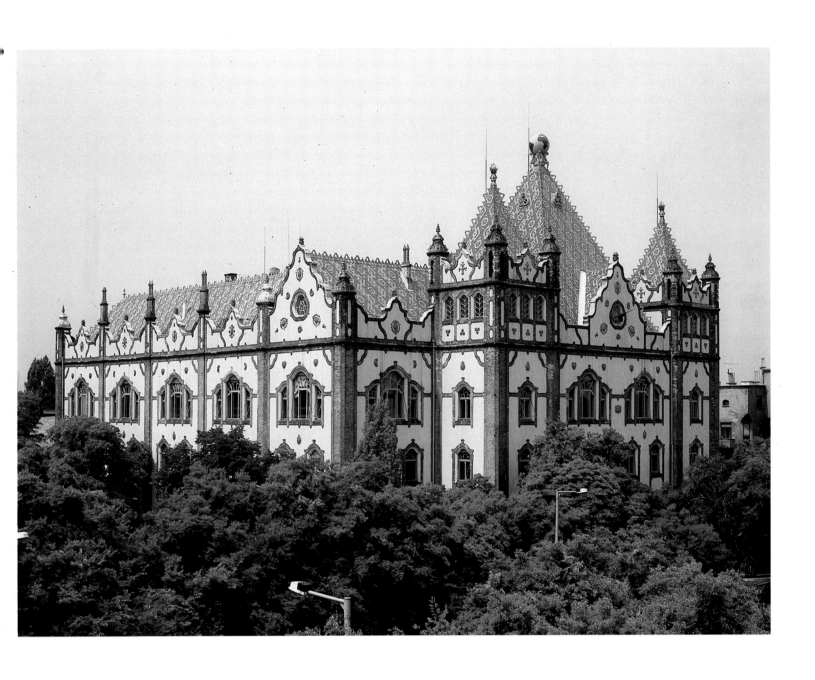

*80.* The Geological Institute of Budapest,
1898–1899
Built by Ödön Lechner

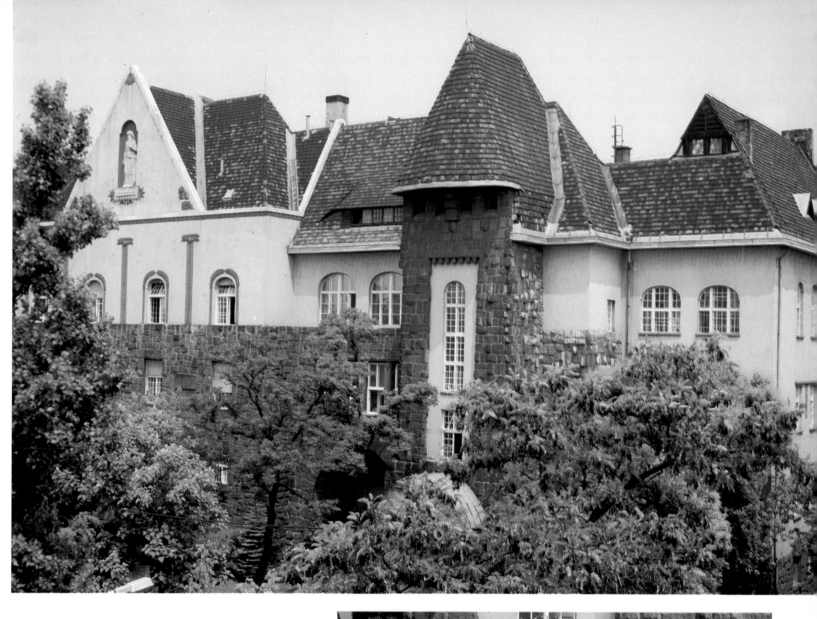

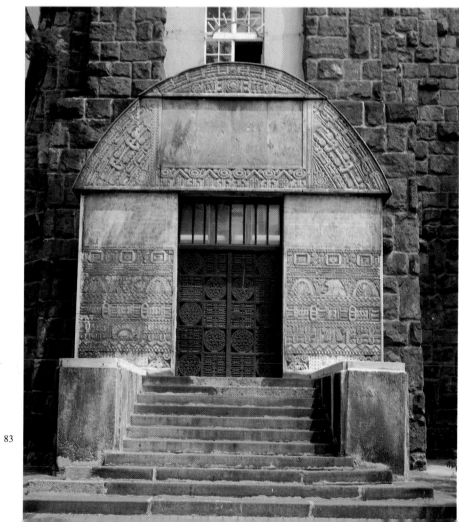

**81.** Detail of the Post Office Savings Bank, 1899–1901
Built by Ödön Lechner

**82.** The façade of the Jewish nursing home in Budapest, 1910–1911
Built by Béla Lajta

**83.** The side entrance of the Jewish nursing home in Budapest, 1910–1911

83

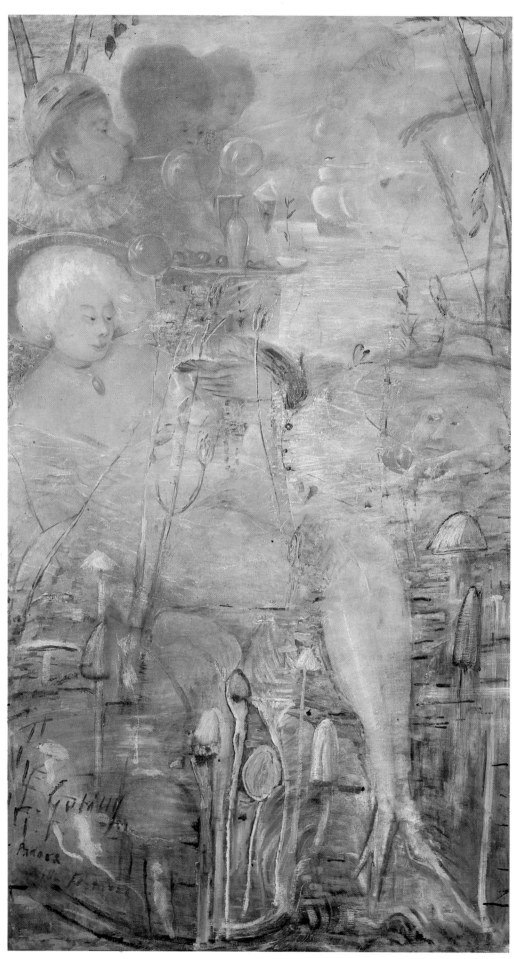

**84.** Lajos Gulácsy: The Dream of the Opium User,
1913–1918
Oil on canvas
Janus Pannonius Museum, Pécs

**85.** Tivadar Csontváry Kosztka:
The Solitary Cedar, 1907
Oil on canvas
Private collection

85

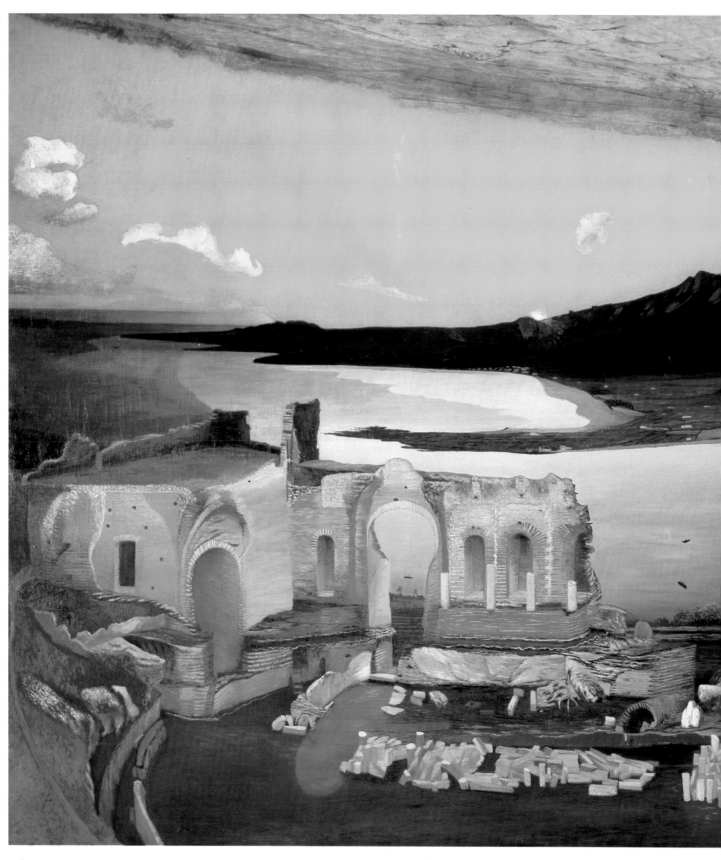

*86.* Tivadar Csontváry Kosztka:
The Ruins of the Greek Theater in Taormina, 1904–1905
Oil on canvas
Hungarian National Gallery, Budapest

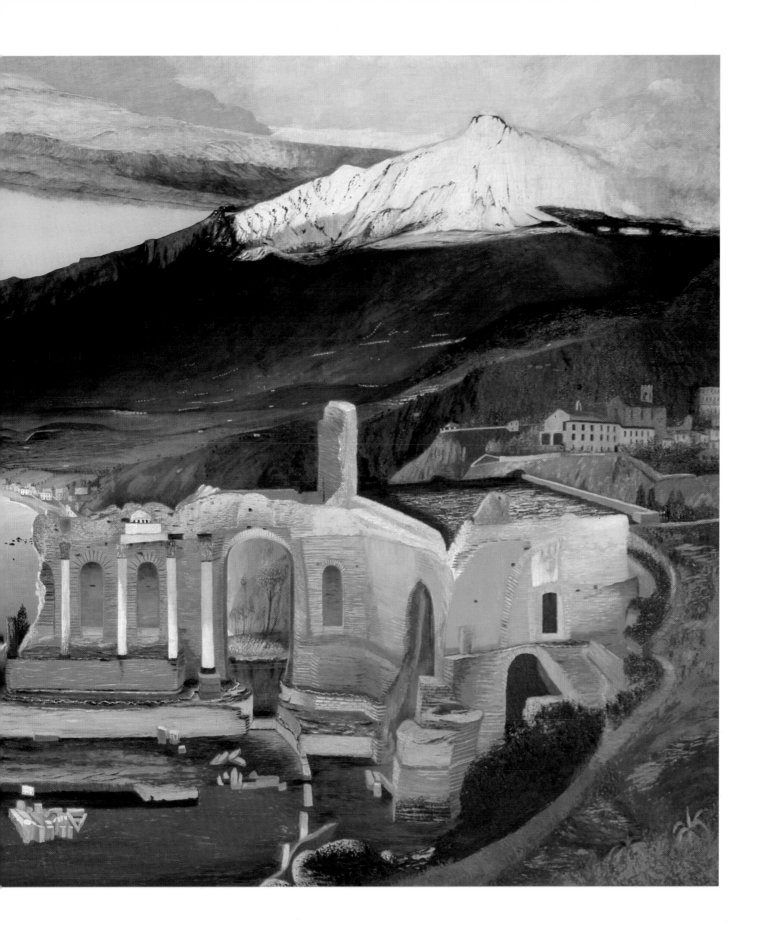

*87.* József Rippl-Rónai: Woman Holding Rose, 1898
Embroidered rug
Museum of Applied Arts, Budapest

*88.* József Rippl-Rónai: Lazarine and Anella, 1910
Oil on canvas
Private collection

88

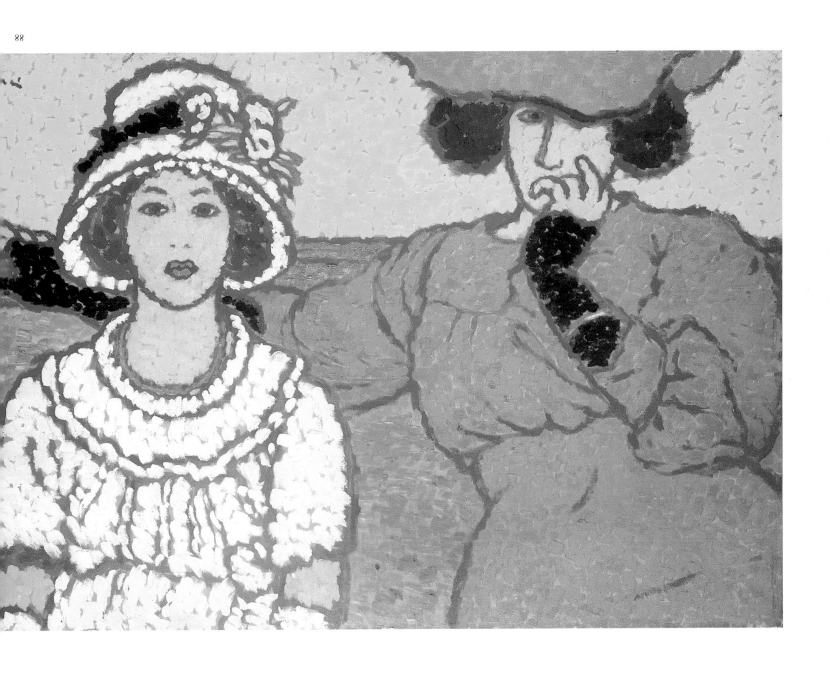

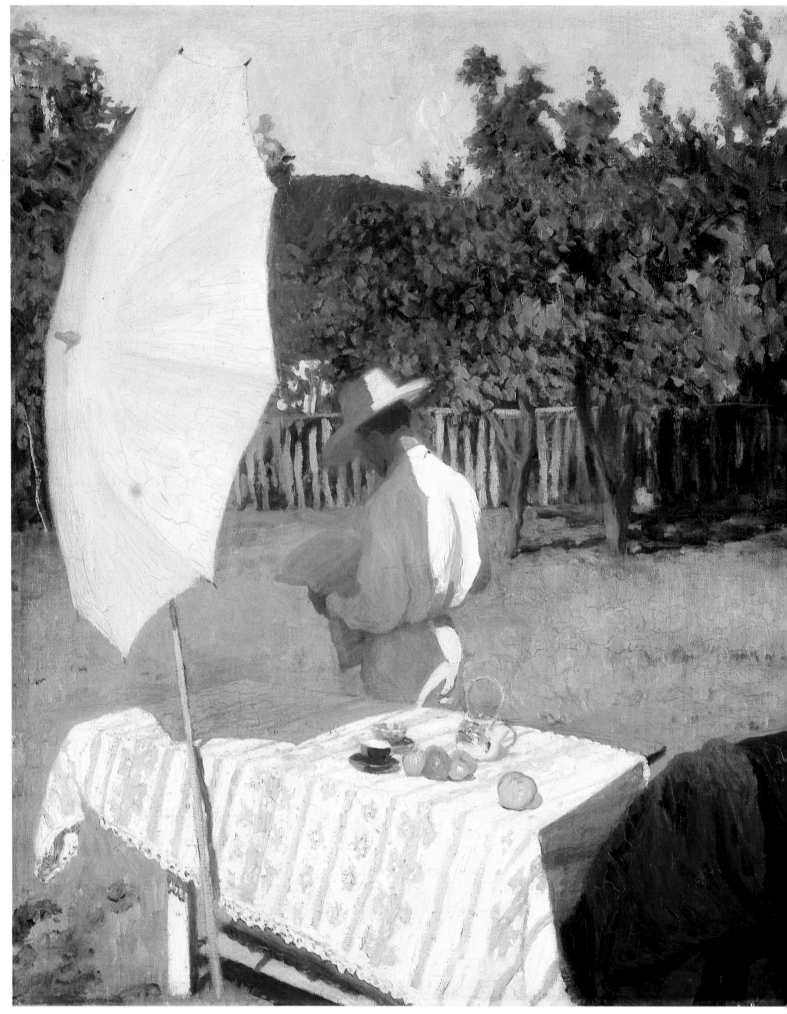

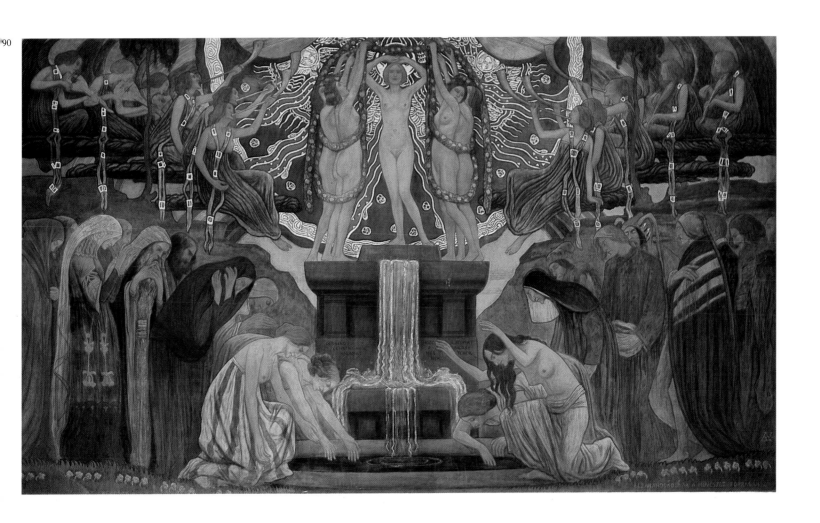

**89.** Károly Ferenczy: October, 1903
Oil on canvas
Hungarian National Gallery, Budapest

**90.** Aladár Körösfői-Kriesch:
The Fountain of Art, 1907
Fresco
Music Academy, Budapest

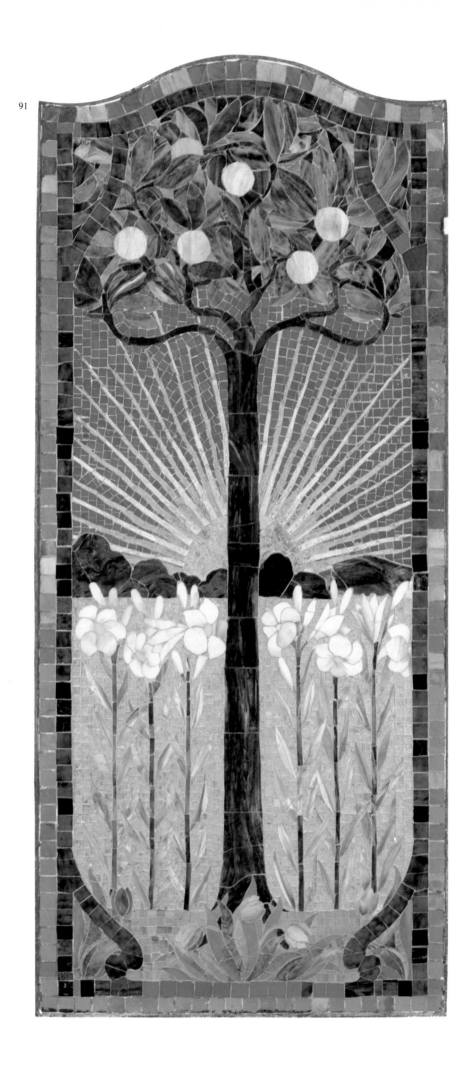

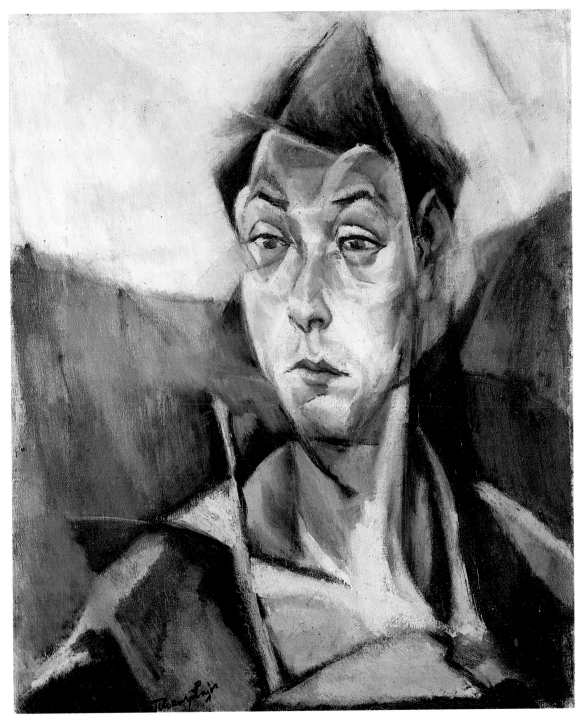

**91.** Miksa Róth: The Rising Sun, 1900
Glass mosaic
Private collection

**92.** Lajos Tihanyi: Self-Portrait, 1912
Oil on canvas
Hungarian National Gallery, Budapest

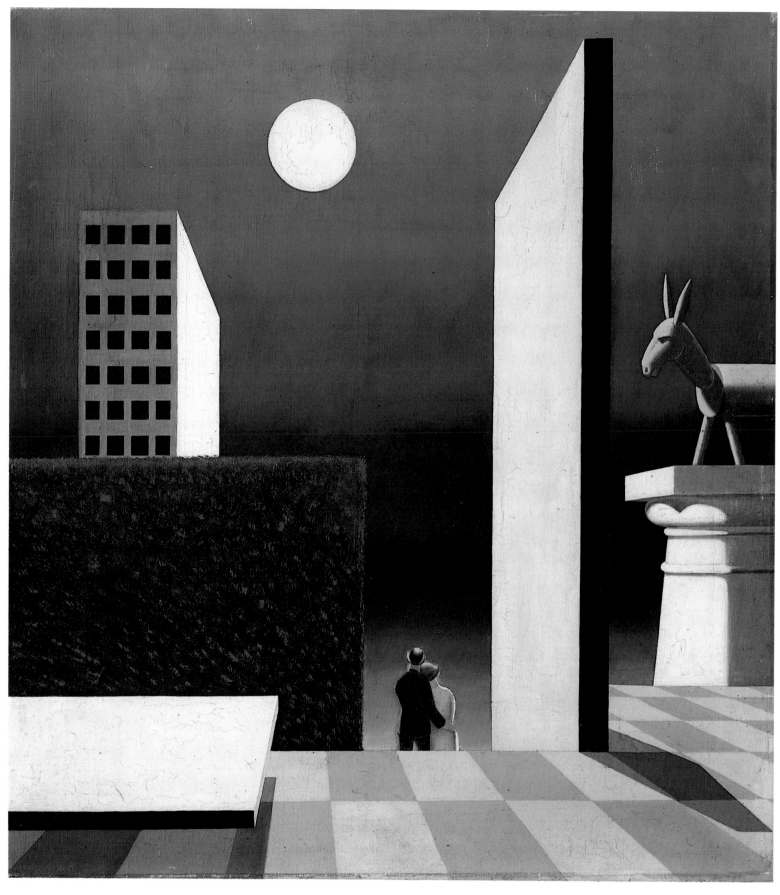

**93.** Sándor Bortnyik: Green Donkey, 1924
Oil on Canvas
Hungarian National Gallery, Budapest

**94.** Gyula Derkovits: Bridge in Winter, 1933
Oil on canvas
Hungarian National Gallery, Budapest

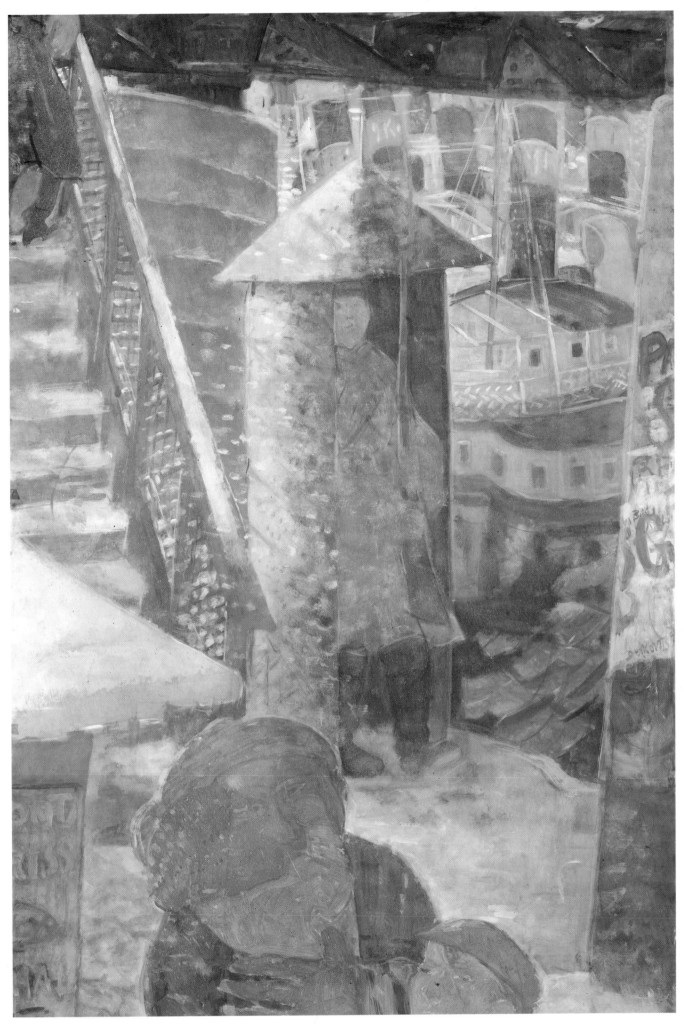

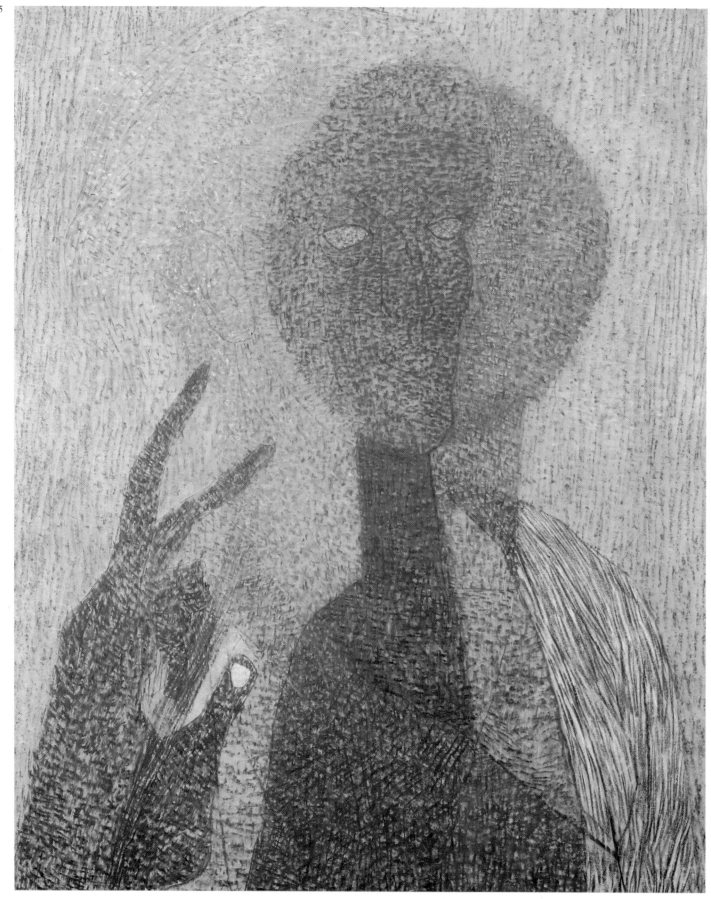

**95.** Lajos Vajda: Iconic Self-Portrait, 1936
Pastel on paper
Private collection

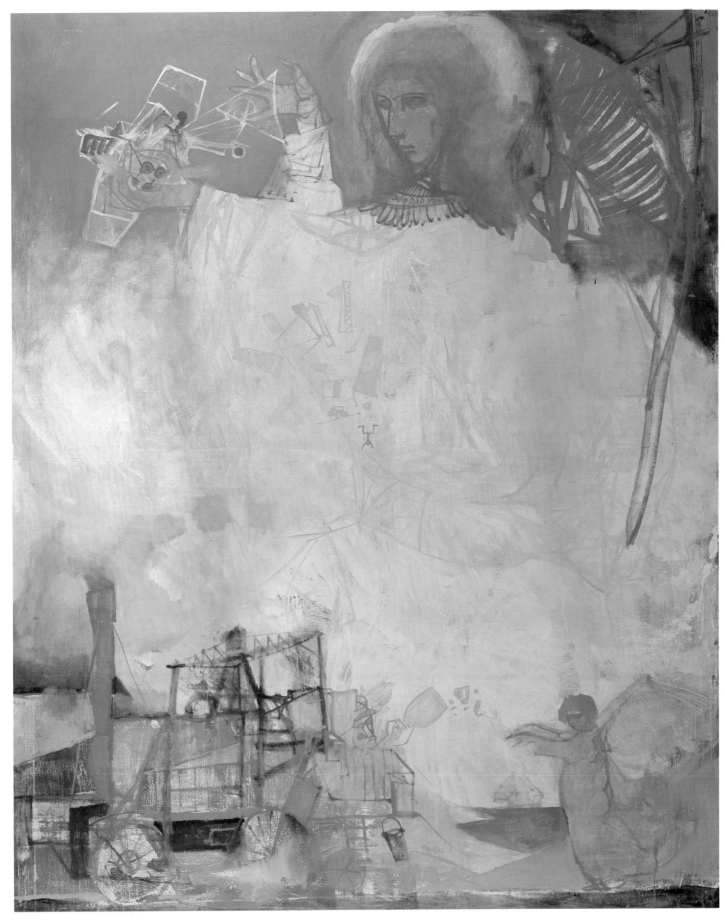

**96.** Béla Kondor: The Genius of the Flying Machine, 1964
Oil on canvas
Hungarian National Gallery, Budapest

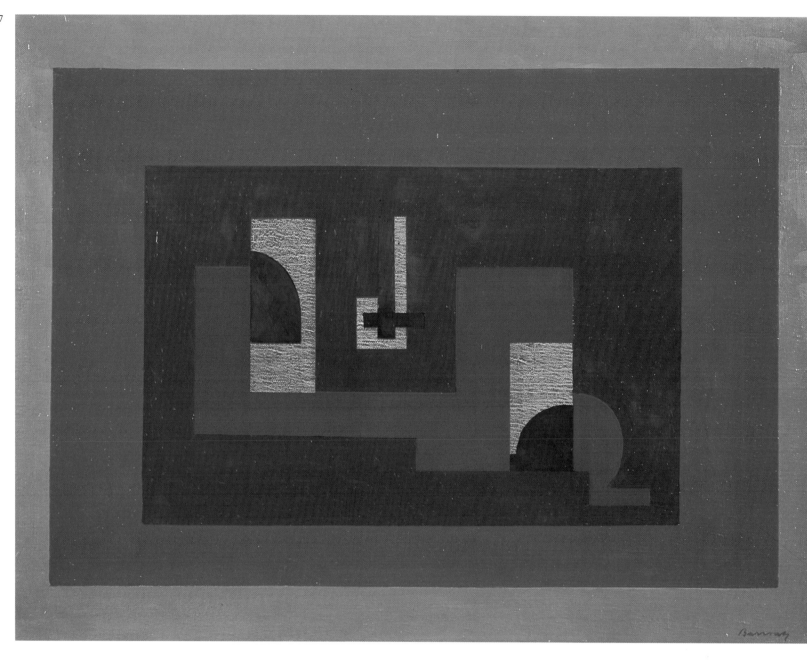

**97.** Jenő Barcsay: Szentendre at Night, 1976
Oil on canvas
Barcsay Collection, Szentendre

**98.** Miklós Melocco: Endre Ady, 1970
Metal, stone
Public Park, Tatabánya

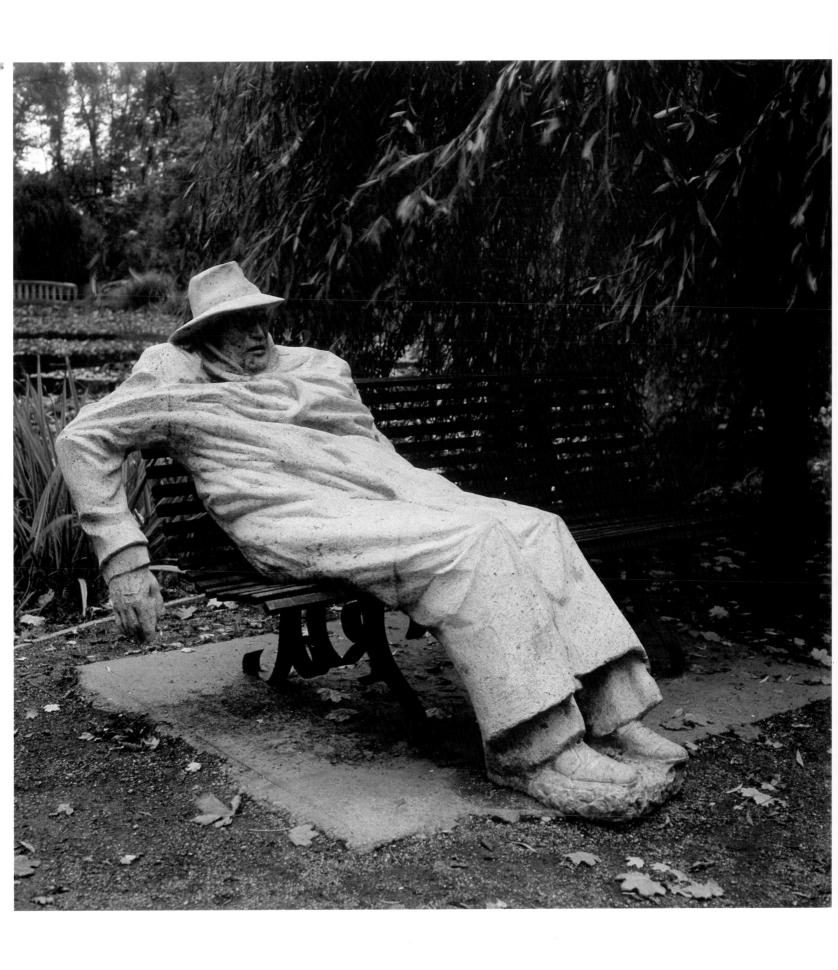

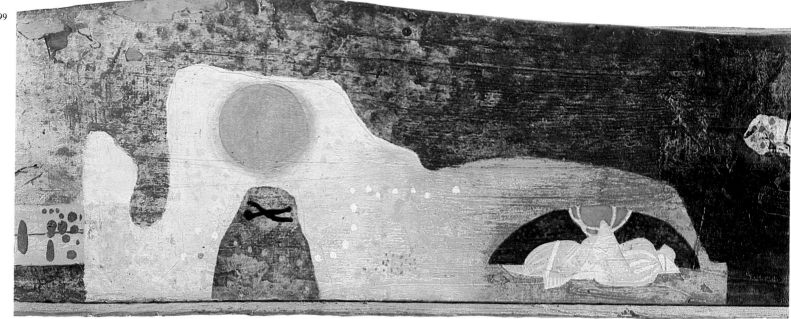

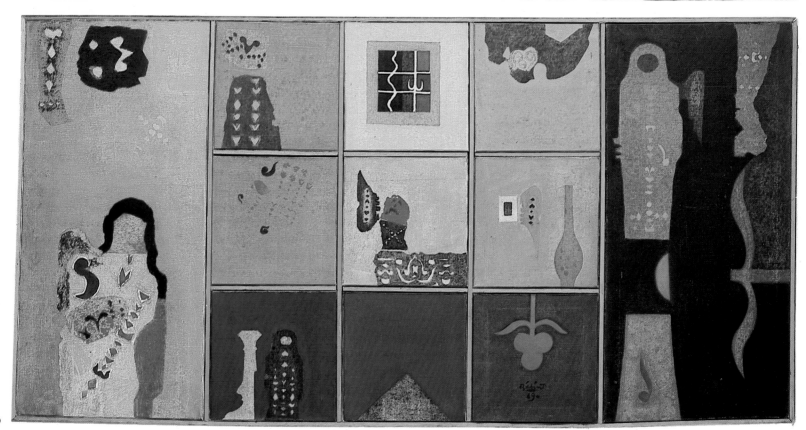

**99.** Endre Bálint: I Was Here Once. Detail, 1960
Oil on wood
Private collection

**100.** Endre Bálint: The Eighth Church of Szentendre, 1969
Oil on canvas
Private collection

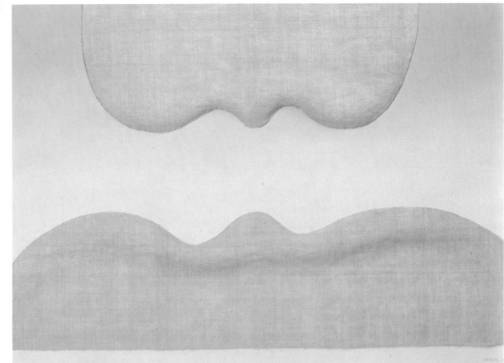

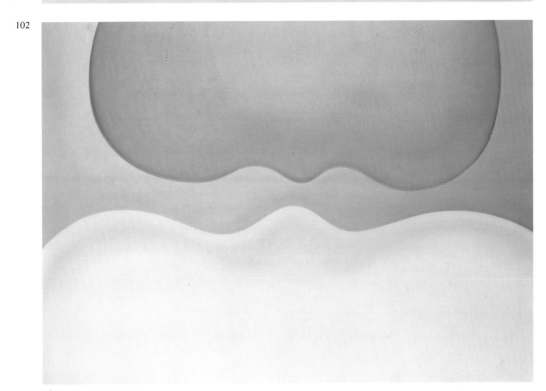

***101.*** Ilona Keserű: Approach II., 1969
Oil on embossed canvas
Private collection

***102.*** Ilona Keserű: Approach I., 1969
Oil on canvas
Modern Hungarian Picture Gallery

103

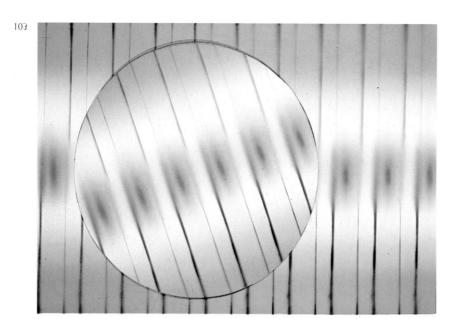

104

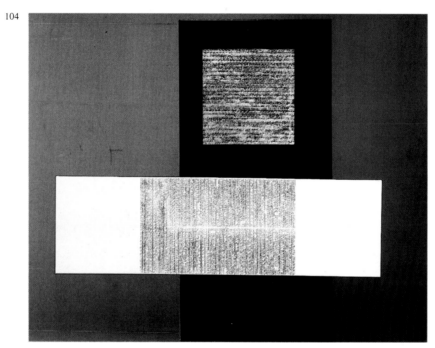

*103.* Tamás Hencze: Motion, 1968
Oil on paper
Private collection

*104.* István Nádler: Hommage à Malevich III., 1981
Acrylic on canvas
Private collection

*105.* The House of Culture in Sárospatak, 1983
Built by Imre Makovecz

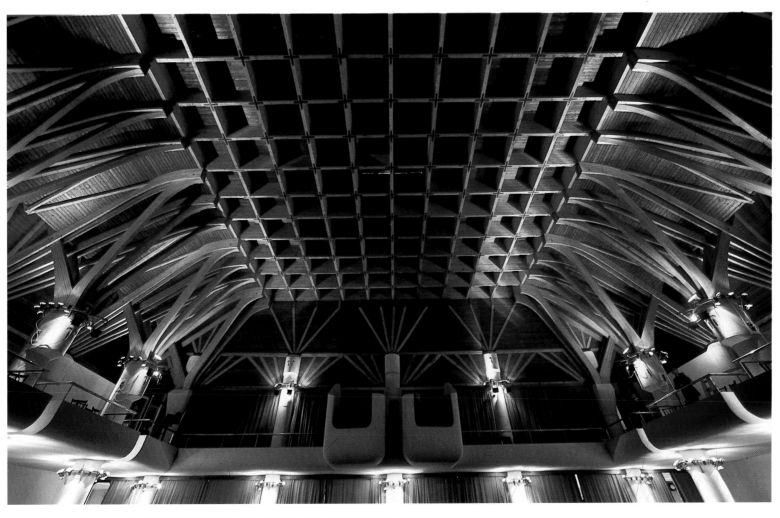

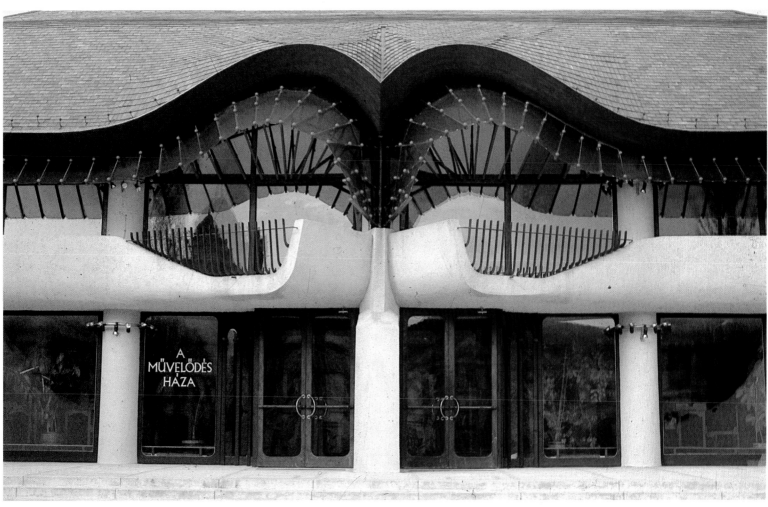

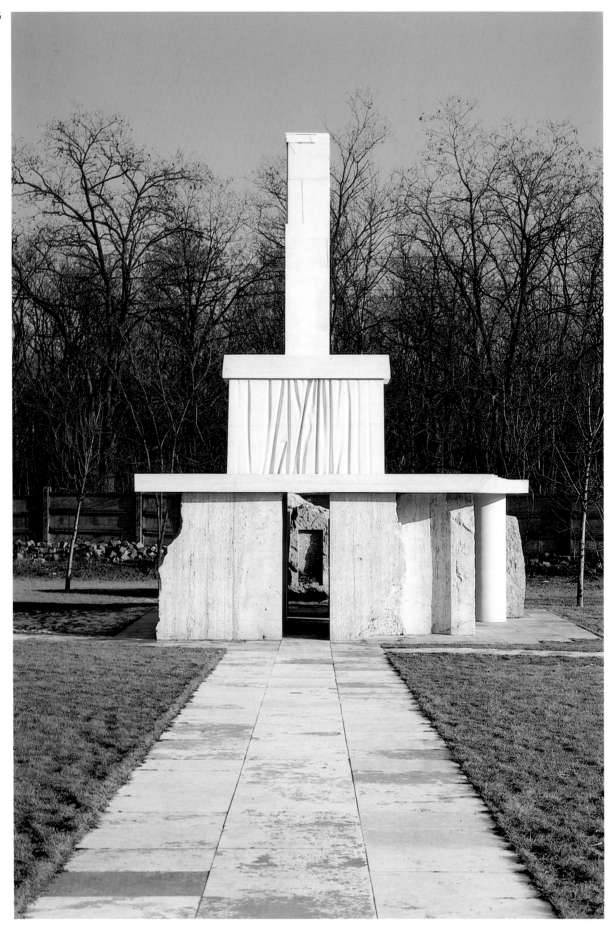

*106.* György Jovánovics: The Monument to the Martyrs of 1956,
1989–1992
Limestone, white cement and black granite
New Public Cemetery of Rákoskeresztúr, Plot Number 301, Budapest

*Sources for the Reproductions*

Lóránd Bérczi *45, 69, 77*
Biblioteca Apostolica Vaticana *18*
Zsuzsa Bokor *16*
László Csigó *79, 106*
József Hapák *64*
Béla Hegede *46, 81*
Attila Károly *100*
Tibor Mester *42, 91*
Metropolitan Museum of Art, New York *19*
Tamás Mihalik *6, 23, 51, 53, 54, 78*
Stefan Millesich *52*
Attila Mudrák *24, 70*
Ann Münchow *17*
National Széchényi Library, Budapest *21*
András Patyi *10, 11, 12, 13*
Endre Rácz *56*
Alfréd Schiller *32, 34, 42, 48, 49, 50, 57, 65, 71, 72,*
     *73, 74, 75, 76, 84, 86, 87, 88, 89, 92, 93, 94, 95, 96*
Károly Szelényi *1, 2, 3, 4, 5, 7, 8, 9, 14, 15, 20, 22, 25,*
     *31, 33, 37, 38, 39, 40, 41, 59, 62, 63, 85, 99,*
     *101, 102*
László Szelényi *43, 55*
Levente Szepsy Szűcs *35, 36, 60, 61*
János Szerencsés *97*
Gyula Tahin *47, 66, 98*
Bence Tihanyi *27, 28, 29, 30, 44*
Ferenc Tulok *58*

*On the cover:* Reliquari of King Saint Ladislas,
     photograph by Károly Szelényi
*On the back:* Master M.S., Visitation,
     photograph by Tibor Mester

Printed in Hungary, 1998
Printinghouse Dürer, Gyula

A kiadvány az ECCO HUNGÁRIA Kft. által forgalmazott
150 g-os EURO ART műnyomó papírra
készült